# BANBURY

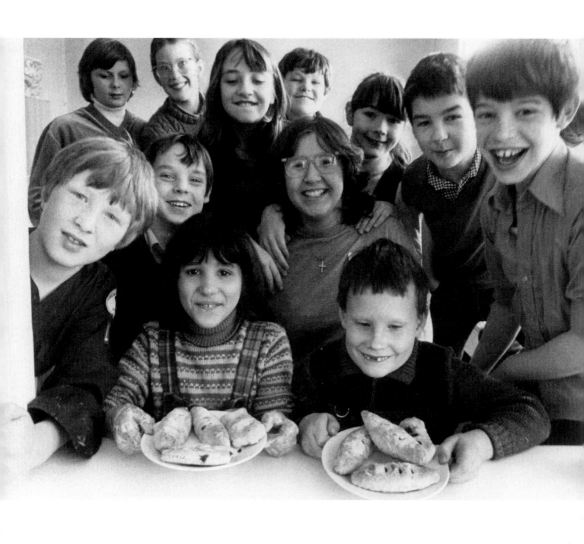

# BANBURY

MARILYN YURDAN

*Frontispiece:* All their own work! In February 1982 these children made their own version of Banbury Cakes as part of a scheme to teach them the town's history. The cakes, consisting of a puff pastry shell filled with a mixture of dried fruit, brown sugar and spices, are thought to have been brought back from the Middle East by returning Crusaders. Pictured holding a part of their own heritage are Elizabeth Denton aged 9 and Kevin Wiltshire aged 7. At one time there were three shops in the town selling these close relatives of Eccles and Chorley cakes but they have not been made in Banbury since Ray Malcolm closed his Middleton Road bakery and High Street shop in 1998. However the recipe was bought by Palace Cuisine of Witney, where they are still made, and can be bought at several outlets in Banbury today, including the Tourist Information Centre and Café Quay inside the Museum.

First published 2010

The History Press
The Mill, Brimscombe Port
Stroud, Gloucestershire, GL5 2QG
www.thehistorypress.co.uk

British Library Cataloguing in Publication Data.
A catalogue record for this book is available from the British Library.

ISBN 978 0 7524 5606 5

Typesetting and origination by The History Press
Printed in Great Britain
Manufacturing managed by Jellyfish Print Solutions Ltd

# CONTENTS

# INTRODUCTION

Banbury is best known today for its Cross, cakes and cattle market, fine lady, cock horse, and in Shakespeare's day, for its cheese. Curiously, the Cross that features in the nursery rhyme was demolished at the beginning of the sixteenth century, the cakes are now made in Witney, the cattle market has closed and nobody can be sure of the identity of the fine lady on the white horse. It is thought that she may have been a Fiennes lady, a member of a prominent local family which includes Lord Saye and Sele whose seat is at nearby Broughton Castle. A state-of-the art lady was unveiled in April 2005 by the Princess Royal. This is a large bronze statue, complete with horse, which stands in the Horse Fair, near the present Cross.

However, the recorded history of the town begins centuries before with a Saxon settlement known as Banna's burgh, which grew up on the banks of the river Cherwell. The Domesday survey notes that in 1086 *Banesburie* was held from the Crown by the Bishop of Lincoln. Bishop Alexander constructed the castle in 1135 approximately where the Castle Quay shopping precinct is now. It was held for the King during the Civil War and successfully withstood a siege over the winter of 1644/5. It was repaired only to be besieged again the following year, when it finally surrendered. In 1648 the House of Commons was petitioned for its demolition, which was partly carried out, and its fabric was used to repair buildings which had been damaged in the conflict. Today no trace remains.

In the Oxfordshire volume of *The King's England* series, Arthur Mee states that Banbury 'has been a strange town in the past for pulling things down. It has mown down its castle, shot its church sky-high, kicked its cross over, and sold its town plate.'

A welcome boost to the town's economy came with the completion of the Oxford Canal in 1790, linking Banbury with the industrial Midlands, the county town and London, via the Thames. The canal was used for freight until the 1930s, and, after a lapse of several decades, has developed into a leisure attraction with facilities for narrowboats. Tooley's Boatyard, adjacent to and forming part of Banbury Museum, has been in use since 1790 and is the oldest working dry dock on Britain's inland waterways and a scheduled ancient monument in its own right.

Unusually for an Oxfordshire town, Banbury has little which survives from its prosperous medieval past due to a disastrous fire which swept through the town in 1628, destroying about a third of its ancient buildings. The fire, followed by the effects of the Civil War, caused a down-turn in Banbury's economy. However, enough remains of old Banbury today to justify the Historical Society's guide to its ancient buildings.

Once an important stop on stagecoach routes, Banbury had a number of coaching inns, some of which survive today, including the Unicorn and the Reindeer Inn. Many little local pubs which had once formed the focus of working class communities were destroyed during the rebuilding of the town centre in the mid-twentieth century. This book includes both survivors and those which have fallen victim to modernisation.

Not surprisingly, the town's economy has had mixed fortunes. For centuries Banbury was a leading centre for the buying and selling of animals as street names like Horse Fair and Cow Fair show. In the mid-1920s Midland Mart developed livestock sales in Grimsbury and at one time Banbury cattle market was the largest in Europe; it closed in 1998. Today it is best known as the home of General Foods and Alcan International Ltd.

The fine medieval church of St Mary the Virgin was replaced by a classical Grade 1 listed building and former chapels of ease have become new parishes. Non-conformists and Roman Catholics are also well represented.

Many twentieth-century events were held in the Winter Gardens, constructed from the Wine Vaults in the High Street, and described at the opening ceremony in 1955 as 'a hall fit for any occasion that might happen in Banbury.' Among the most popular activities were dances and other musical events, as well as roller skating, wrestling, boxing, dog and fashion shows, but no theatre. The Winter Gardens closed in the 1980s and its site became a car park in Calthorpe Street.

Two of the highlights of the Banbury year were the rag week in spring, organised by the North Oxfordshire College and School of Art & Design to raise money, and the town carnival, which took over the streets in the summer. From 2000 onwards the Hobby Horse Festival, held in early July, has taken over, but there a whole range of social activities are held in the town throughout the year.

The last chapter of this book takes a look at the young people of the town, from toddlers to teenagers. Banbury Grammar School was endowed in the reign of Henry III to provide free education for sixteen pupils. Its descendent, today's Banbury School, dates from 1967 when four schools were amalgamated. The town's first public secondary school, the Municipal Secondary and Technical School, was opened in 1893. Thirty years later, on its move to Ruskin Road, it changed its name to Banbury County School. When a Technical School opened in 1950, the school reverted to its old name of Banbury Grammar School. The North Oxfordshire College and the Oxfordshire School of Art & Design have become part of Oxford and Cherwell Valley College.

Twenty-first-century Banbury is the second biggest town in Oxfordshire and the capital of the surrounding area, which is still sometimes referred to as 'Banburyshire'. Today the town has plenty to offer both residents and visitors. It has a large modern shopping complex, a state-of-the-art museum and Tourist Information Centre, a fine Georgian church which doubles as a concert venue, many pubs, bars and restaurants and good social and sporting facilities.

*Marilyn Yurdan, 2010*

# ❧ 1 ❧

# THROUGH THE STREETS

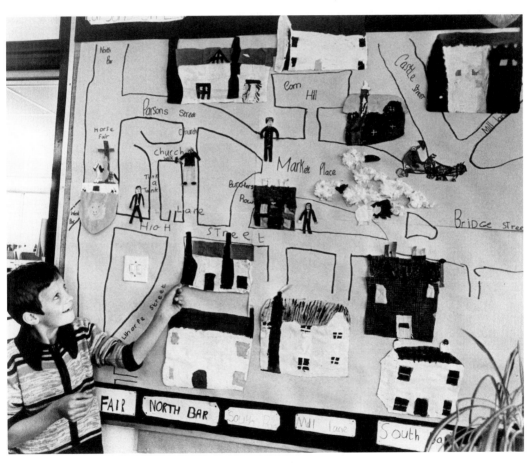

In June 1982, pupils at William Morris School presented the findings of their project to record Banbury's town and people as it was then. Their work included making this large-scale map of the town centre, demonstrated here by 8-year-old Darren Mabbitt. Apart from being a useful history lesson in its own right, the map is valuable because it shows this part of Banbury as it looked before the wide-reaching rebuilding of the Market Place and Corn Hill areas, which were to be altered beyond recognition by the expansion of the Castle Quay Shopping Centre in the 1990s.

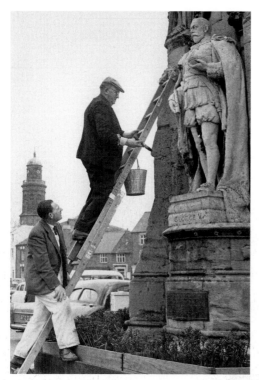

*Left:* These two Borough Council workmen, Mr Jack Green and Mr Arthur Wyatt, are busy cleaning up George V, one of the three statues at the base of the Cross, March 1966. They made such a good job of it that the figures were reported to have shone white in the spring sunshine, the result of the application of water, a soft brush and plenty of elbow grease. In 1960, in a bid to ease traffic congestion, certain residents of Banbury, acting in the spirit of their predecessors, had demanded that the Cross be taken down and traffic lights be put up in its place.

*Below:* These three men were part of a committee formed in 1962 by the Banbury and District Civic Society to study and evaluate proposals for improving façades in the town. They are, from left to right, Mr D. Ingram, Mr M. Blinkhorn and Mr J. Neal. Of particular relevance at this time were the plans for a new-look Horse Fair.

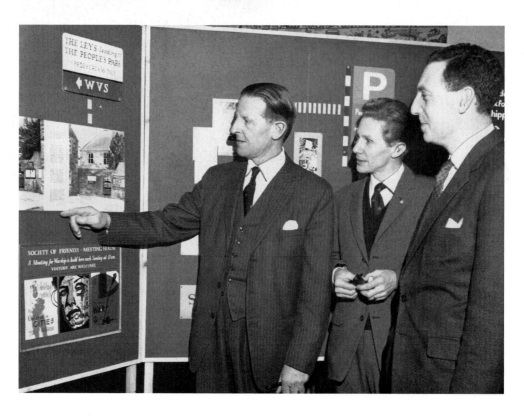

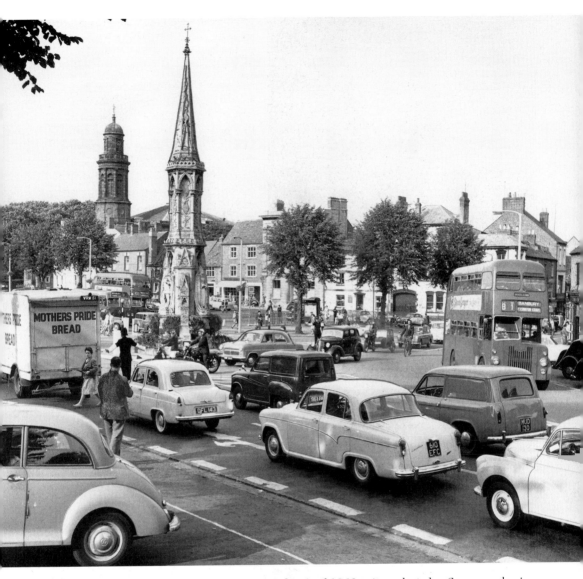

The area around the Cross was just as congested in April 1962 as it can be today. Cars, vans, lorries, motorbikes and even double-decker buses are to be seen milling around in all directions. Without traffic lights or zebra crossings, the policeman on point duty was very necessary.

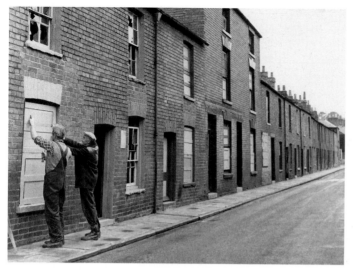

Council workmen boarding up windows of houses in Lower Windsor Street, which were due for demolition, in October 1962. Plans had been approved by Banbury Town Council to demolish properties in this street, Lower Cherwell Street, George Street and Canal Street as part of a five-year slum clearance programme.

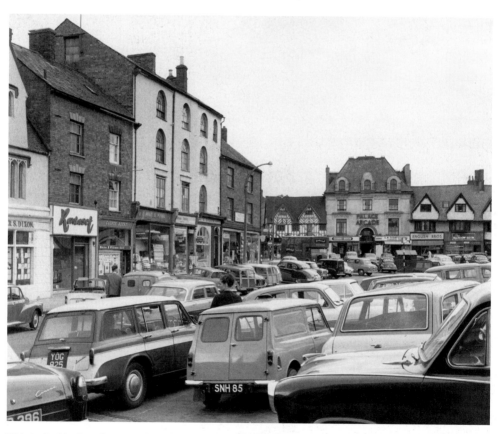

This is the Market Place in July 1964, when rebuilding was being considered. In the days before municipal car parks, every available inch of road was used for parking and it is difficult to see how some of these motorists would have been able to drive away without waiting for their neighbours to move their cars.

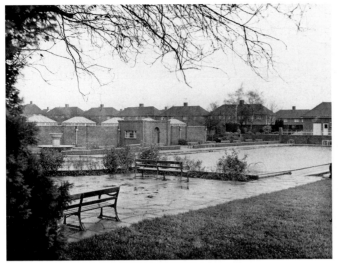

Not surprisingly, there were no swimmers taking advantage of the rain-swept Borough Open-Air Swimming Pool at Wood Green, shown here in November 1963 when a proposal had been made to cover it over and heat the water. Opened on 23 May 1939, it was very much part of the local scene and in 1999 almost 1,500 people used it over the Bank Holiday weekend. It has been closed since 2002 but in April 2005 the Open-Air Pool Support Group, backed by a 10,000-name petition, launched a determined campaign to modernise and re-open it.

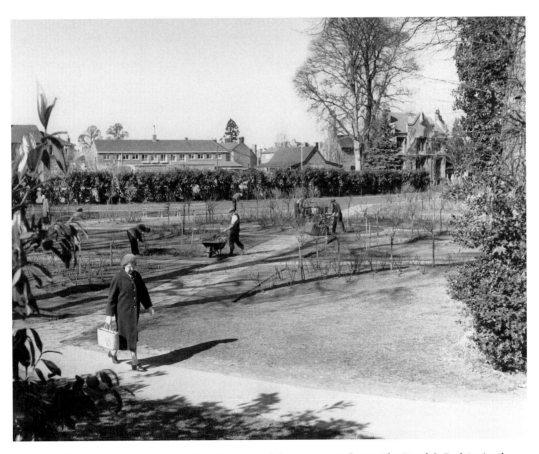

Gardeners in the rose garden take advantage of the sunny weather in The People's Park in April 1965. The 3-hectare park was given to the people of the town by George Frederick Ball in 1897 as part of the celebrations for Queen Victoria's Diamond Jubilee.

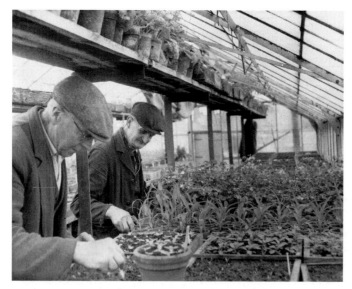

In April 1965 unemployment was so low that there was a staff shortage at The People's Park. Even with the offer of housing being included there were still not enough skilled men to cope with the summer displays. Mr E. Giles and Mr H. Peverill are shown working with lobelia seedlings in the park's greenhouses.

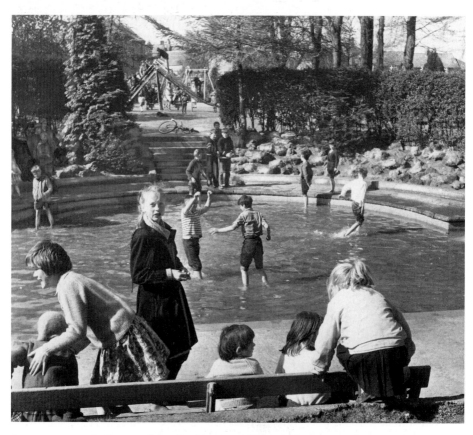

Summer came to Banbury in the spring of 1967, as these children show. They are paddling in the pool at People's Park on 5 April, although it should be noted that only the boys have been rash enough to strip off, the girls sensibly hanging on to their cardigans and hoods, coats and scarves.

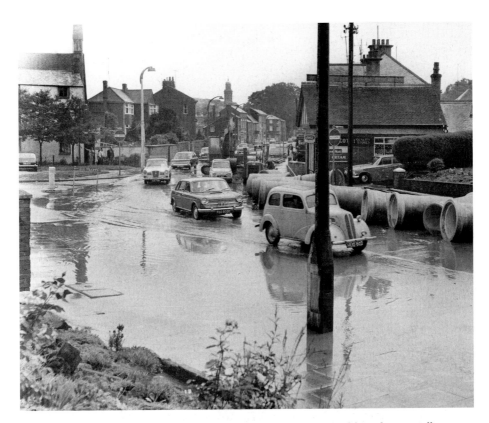

A flooded Warwick Road following a freak storm in August 1965. Although a partially-completed surface water drainage scheme costing £132,000 withstood its first real test, it did not extend beyond the junction with Warwick Road and Neithrop Avenue, which meant that residents in this area were still experiencing the twenty-year-old problem of lifted man-hole covers, flooded roadways and discharged sewerage.

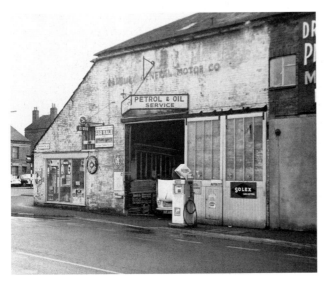

In December 1966, Banbury General Motor Company's garage in Warwick Road was reported to have been sold to Mr W.P. Gilkes for an undisclosed sum. The site had been part of Dunhill's brewery then it was used by Booth's builders, becoming a garage in 1919 when Aubrey Blencowe started up his business there. Following Mr Blencowe's death during the Second World War, it was carried on by his partner, Mr W. Gibbard, then his widow and then by their son, Fred.

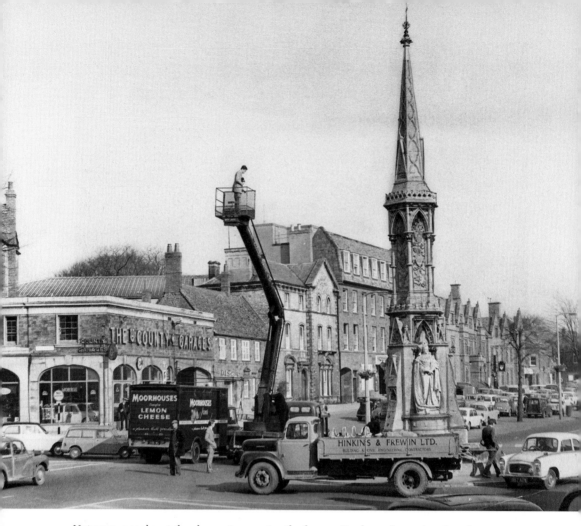

Not many people get the chance to examine the famous Banbury Cross at such a close range as this photographer did in March 1965. He was preparing evidence to show the Borough Surveyor's Department what needed to be done as part of a facelift for the Cross, which was carried out the following year.

*Opposite above:* One of Banbury's oldest shopping areas, Parsons Street, in April 1967. At this time it was noted by an *Oxford Mail* reporter as still being 'a feature of the Banbury of the future.' Apart from the models of the cars and shop names, the main difference from how Parsons Street looks today is the enormous sign for the Reindeer which jutted out over the thoroughfare.

*Opposite below:* This photograph was taken in December 1967 shortly after a new shopping area for the town had been proposed. At this time it was uncertain whether it would be centred on the castle site or the area bounded by Market Approach, Castle Street and Bridge Street. In the event, Lamprey's wholesaler at No. 34 survived; this building was bought in 1834 by John Lamprey for his company's headquarters and features today in Banbury's Historic Town Trail.

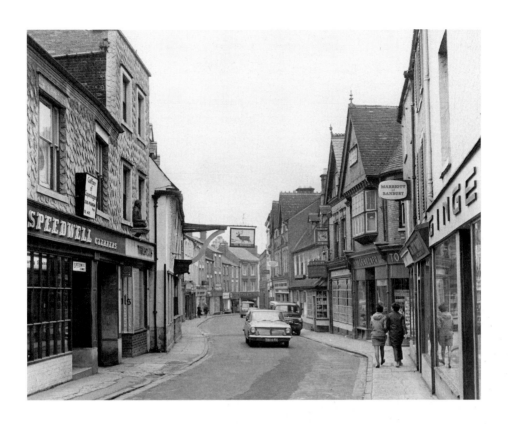

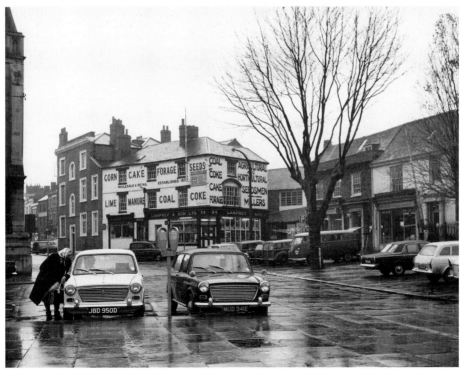

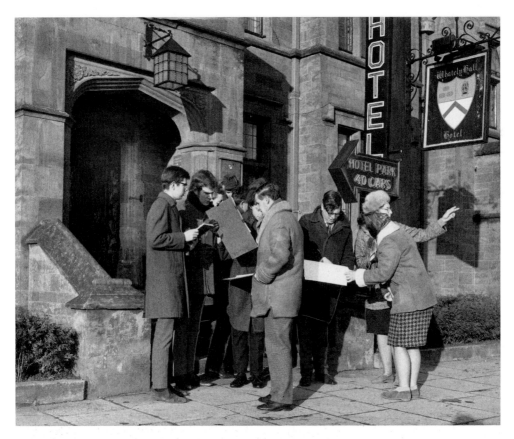

In January 1968, fifteen members of the Oxfordshire branch of the CPRE (Council for the Preservation of Rural England) spent a day touring Banbury to inspect its historic buildings prior to preparing a survey of the listed buildings, of which there were more than 100 in the town. They are shown here leaving the Whately Hall Hotel at the start of their tour.

By January 1968, Banbury Corporation's Municipal Offices in Marlborough Road were in such a bad state that the cost of repairs to the stonework was estimated at £4,500. The site was roped-off during repairs as a precaution to prevent people being struck by falling masonry; the only section still accessible was the public library. A spokesman stated that although falling masonry was a hazard, there was no danger of the building falling down.

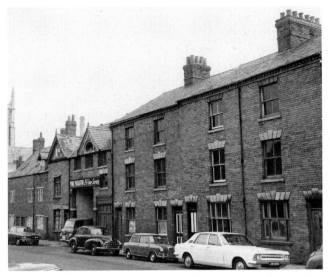

This is the site in Broad Street which had been ear-marked for a garage in February 1968. Banbury Co-operative Society had just revealed plans to build a 24-hour petrol station and garage which would involve the demolition of this group of uninhabited, red-brick terraced houses. Plans for a 'note exchanger', a pump dispensing £1 worth of petrol when a motorist inserted a pound note, were turned down.

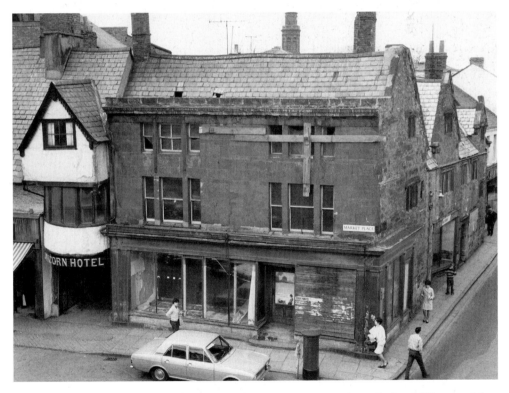

In April 1968 the CPRE stated that it would be seeking a preservation order on Prebendal House and the Unicorn Hotel in Market Place. A spokesperson said that they were most anxious to avoid a repeat of the demolition of the Banbury Cake Shop. Known as the Original Banbury Cake Shop, this building dated from around 1550, although an early bakery existed as early as the thirteenth century. The Museum in Castle Quay has exhibits from the shop. The spokesperson added that the Prebendal House was virtually the only surviving medieval building in the town, but in fact it dates from the seventeenth century.

This photograph, taken in August 1968, shows Crouch Street from Trinder's shop and facing away from South Bar. This wide road with its Georgian-style architecture (it was laid out about 1840) is very different from the streets of small terraced houses which were being pulled down in other parts of the town.

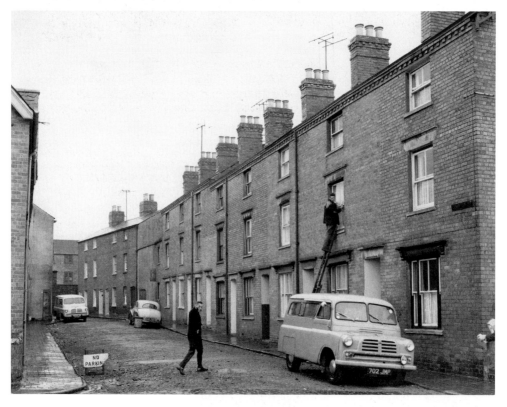

Compton Street, photographed in April 1969 before its demolition as part of the Market Place Development Plan. Compton Street was just one of several streets made up of terraced workers cottages which had to go. Those in Banbury are not typical in that they have three storeys instead of the more usual two.

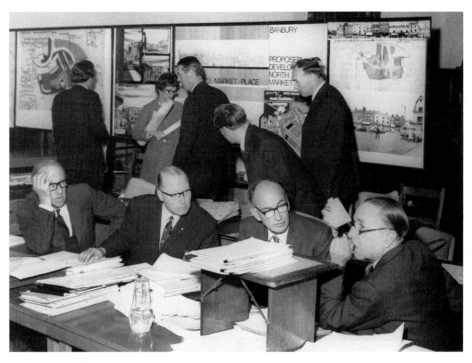

At the opening of the public inquiry into the three major proposals for the town centre redevelopment in Banbury in April 1970, Mr Harold Marnham QC said that Banbury was 'a town of character, charm and considerable attraction and, as such, well worth preserving.' Here Town Clerk Mr F.G.E. Boys (second from the left) discusses the town council's plan with Mr Markham (right).

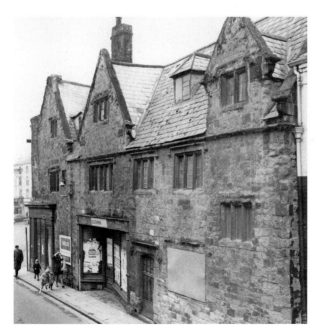

In April 1970, the CPRE announced that it had no objection to plans to convert the Prebendal House, a former post office, into shops and offices providing that its façade in Parsons Street was retained. A spokesman said, 'As long as the development is nicely designed we shall be content.' There is no evidence to support its name of Prebendal House.

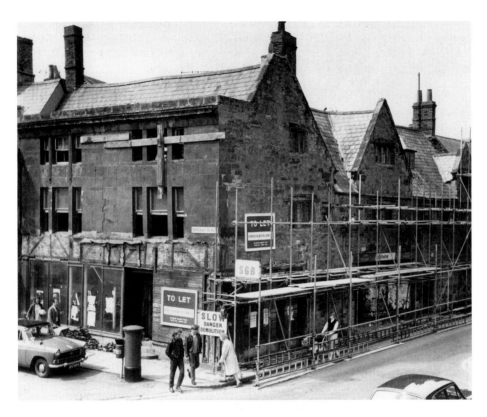

*Opposite above:* Two listed buildings, the Prebendal House and Old Post Office, under scaffolding at the start of its facelift in 1970. The owners, Birmingham brewers Mitchell and Butlers Ltd, had sold the premises to a London property development which turned it into shops. The interior was torn out ready for conversion by Banbury firm J.W. Rogers and Company.

*Opposite below:* In February 1973 two more listed buildings, which had been saved from demolition, were destined to become offices. These were Nos 18 and 19 Market Place, Moore's cake shop and the entrance to the Unicorn Hotel. The site was bought by the Nationwide Building Society, which said it would be necessary to spend more on refurbishing the buildings than it had to actually purchase them.

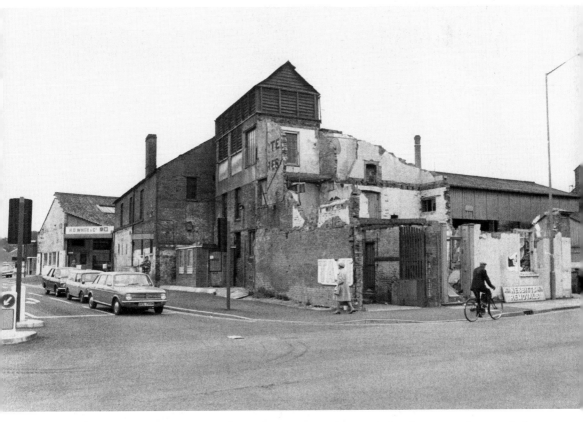

This partly-demolished building at the junction of Cherwell Street and Bridge Street, photographed in September 1973, was the subject of negotiations concerning its future between land owners and Oxfordshire County Council. The demolition began as part of the council's Cherwell Street improvement scheme the previous year, but at this time negotiations with the owners were said to be at 'a very delicate stage.'

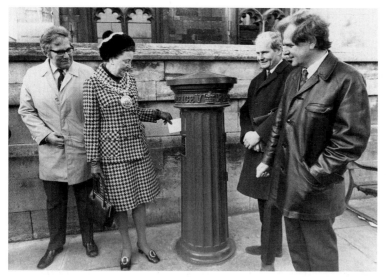

The Mayor of Banbury, Miss Florrie Woolams, is shown posting a letter in a 117-year-old post-box, watched by Mr Geoffrey Lester, Banbury postmaster Mr Keith Bennett and Mr Bill Harding. The box at the Town Hall, which had previously been positioned at the junction of Cherwell Street and Bridge Street, but was moved due to redevelopment, was officially opened in November 1974.

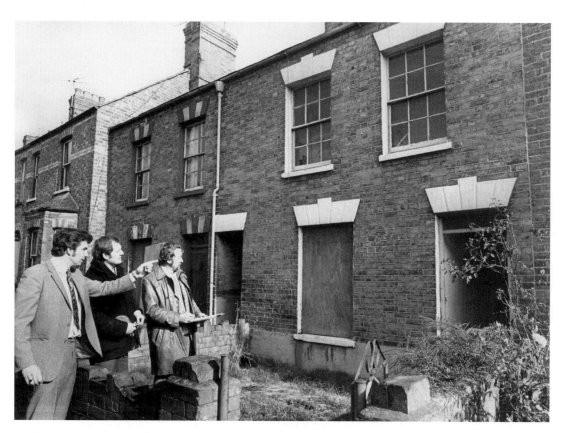

Improvements in Grimsbury in February 1975 were designed to dispel the reputation of the area's having become something of a 'ghost town'. Three members of the Architect's Department of Cherwell District Council, Mr Reuben Blencowe, Mr Stephen Underwood and Mr Michael John, inspect a trio of houses in West Street.

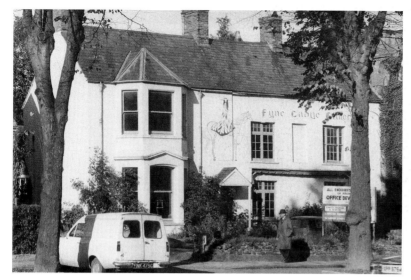

Permission to demolish the eighteenth-century Fyne Ladye Gallery at No. 47 The Green was given in October 1976, because, it was claimed, it disrupted the street scene. Cherwell District Council had previously refused permission as it was a listed building in a conservation area, but the Secretary of State for the Environment, Peter Shaw, overturned their decision after an appeal by property developers.

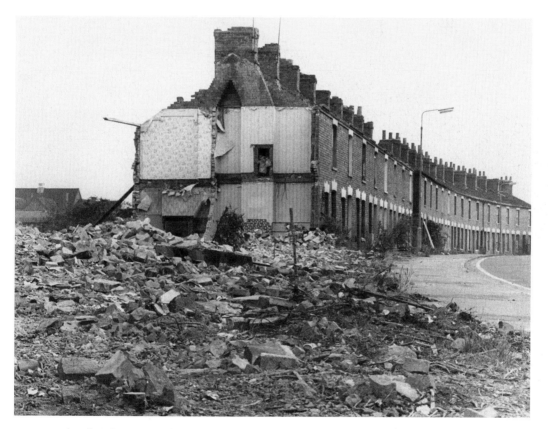

Further demolition took place in October 1978, this time in Grimsbury where thirty-seven houses in The Causeway came crashing down. It was expected that within the year the urban landscape would have begun to take on an altogether different look and would include new homes and bungalows for senior citizens.

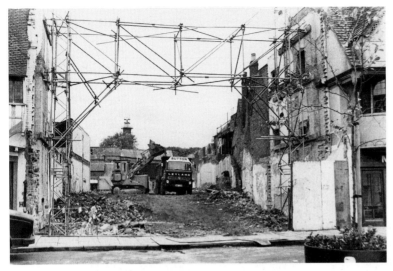

This gap in the façades of Market Place, photographed in November 1979, was once the site of the Palace Cinema and then became a toy fair. As part of a further redevelopment, the façade was reconstructed as that of the new Midland Bank, which welcomed customers through the door in 1981.

A tractor trundles past the Town Hall on a wet September day in 1976. This Victorian building, designed by Bruton in the Gothic style and opened in 1854 (with additions made to the southwest in 1891), houses Banbury's two civic maces and some valuable paintings as well as the Twinning Tapestry made to commemorate twenty-five years of twinning with Hennef in Germany in 2006.

# EVENTS

This 350lb stone, which was rediscovered in a Banbury Rural District
Council storehouse, commemorates a murder which took place at
Williamscot Hill, about 3 miles from the town. It is known as the Kalabergo
Stone after jeweller and watchmaker John Kalabergo, who was inexplicably
shot dead by his nephew Gulielmo in 1852. The stone is shown here in a
temporary position outside the Council Offices in August 1961.

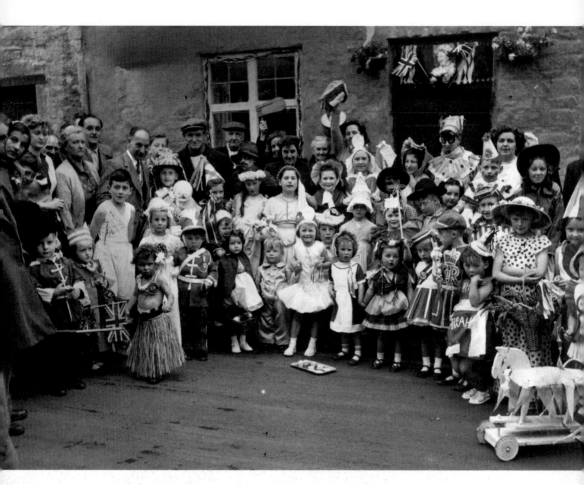

The Queen's Coronation in 1953 was celebrated with style in Calthorpe Street as elsewhere all over the country. The children in this photograph, wearing a great assortment of costumes, were lined up ready to take their place in a fancy-dress parade. There appear to be several Fine Ladies among the participants, and even a White Horse!

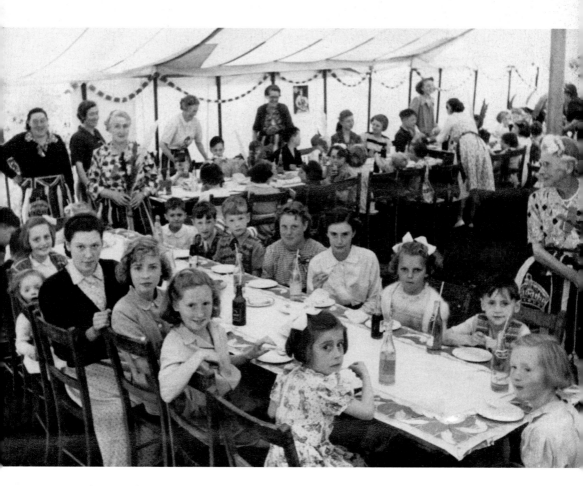

In Broughton Road the highlight of the celebrations was the Coronation party on the Saturday. This was held in a marquee which had been erected at the end of Bath Road. Children living in the road were waited on by their mums and other willing helpers. Following the austerity of the war years, any sort of treat was doubly welcome as sweet and sugar rationing had only ended in the February of that year and food rationing did not finish completely until July 1954.

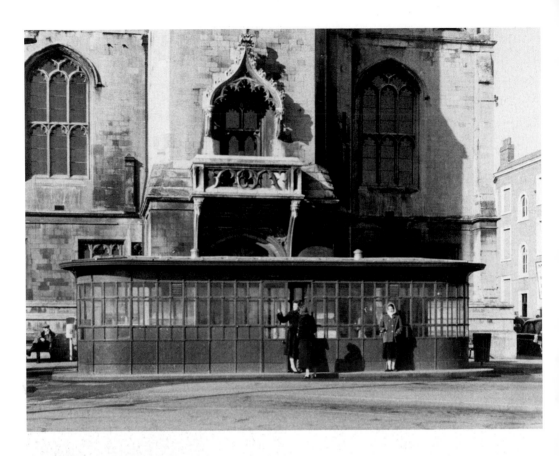

*Above:* Royal visits usually bring to mind fun things like bunting, flowers and Union Jacks but more practical measures are occasionally needed. Preparations for a visit from the Queen in April 1959 included the dismantling of this iron bus shelter. Above it is the balcony on the Town Hall on which the Queen would appear on 8 April.

*Left:* People pause to watch as firemen deal with a 'fire' on Banbury Town Hall roof in October 1963. The fire-fighter on the ladder was dealing with a mock blaze and a smoke bomb had been let off to draw people's attention to a Home Safety Exhibition which was being held inside the building.

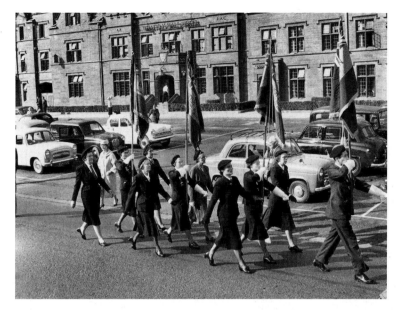

A Battle of Britain parade was held in Banbury in September 1959 to mark the historic event which had taken place in August and September 1940. Standard-bearers from the Royal British Legion Women's Section are shown marching past the Whately Hall Hotel. Among those also taking part was party of USAAF men from the base at Upper Heyford.

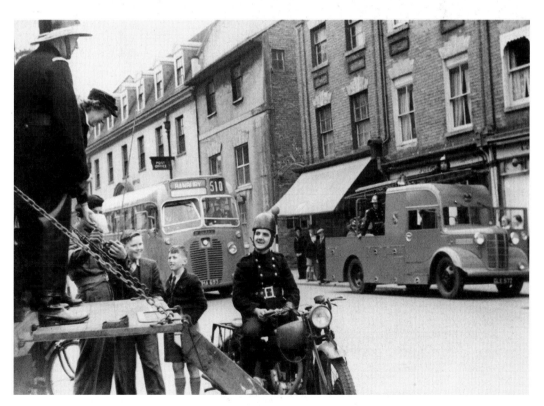

This cheery dispatch rider with reinforcing fire appliances is shown reporting to a mobile zone fire control point in the town centre during a series of tactical exercise which took place in Banbury in April 1954. The soldier holds a walkie-talkie with a very long aerial with which to summon anything else that might be needed.

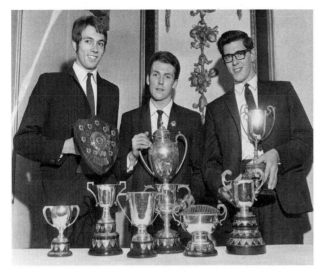

These three young Banbury men walked off with most of the cups at the Banbury Star Cycling Club's seventy-fifth anniversary dinner at Wincott's Café in November 1966. They are, from left to right, Phil Puryer, Roy Douglas (club champion) and Chris Puryer.

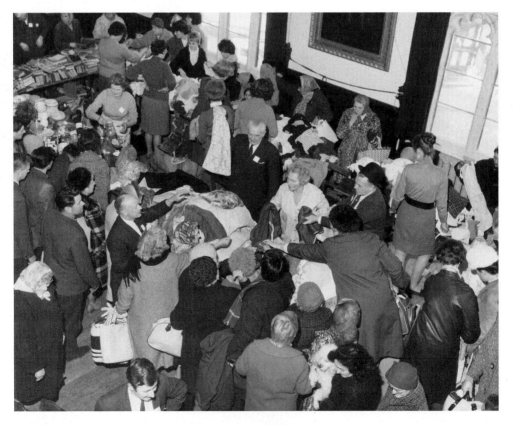

The Town Hall was taken over in February 1968 for Banbury Rotary Club's mammoth jumble sale. With an amazing range of articles, from a hairbrush to a piano, for sale on forty stalls it was a great success and raised £405 to be added to the £2,205 already collected in order to buy four more special all-purpose beds at Horton General Hospital. Banbury Rotarians had already found the money for six beds.

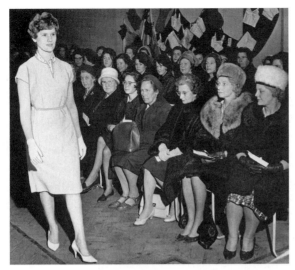

Fashion shows were always popular with ladies in the 1960s and they were often held to raise money for charity. A combined dress show and demonstration of floral arranging was held at Marlborough Road Methodist Church schoolroom in April 1964 in aid of the Ockenden Venture which helped refugee children. The show was organised by Susan Evans of Banbury and shown modelling the spring collection is Judy Floyd.

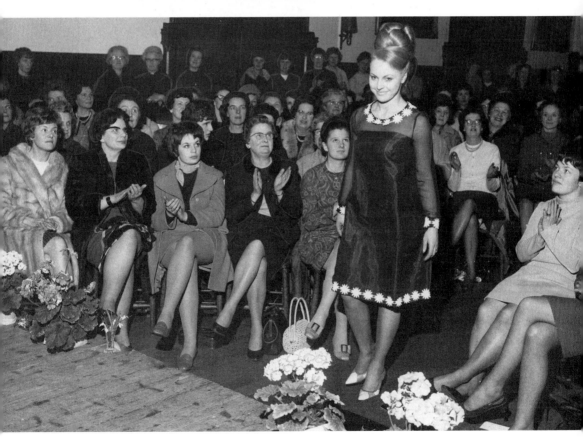

Another fashion show put on by eight members of the Banbury Ladies' Circle at the Town Hall in March 1968. This was complemented by a demonstration of hairdressing techniques given by a Banbury hair salon and modelled by Sandra Griffin, whose elaborate hairstyle seems to be appreciated by the ladies in the photograph.

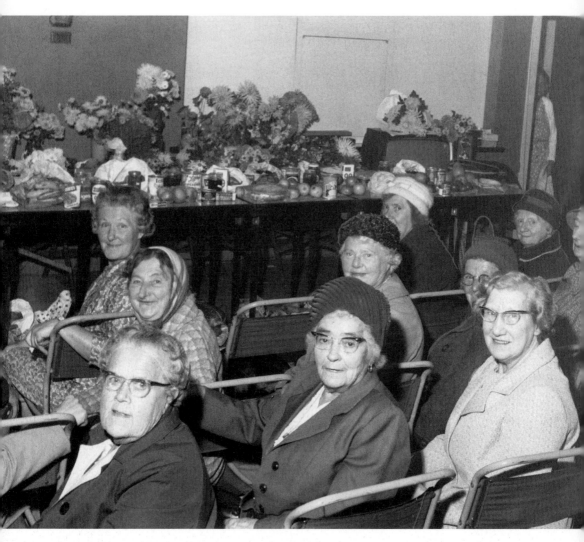

Instead of their usual Wednesday meeting, these members of Banbury Old People's Club held their own harvest festival in October 1970. Afterwards the produce was raffled off, tickets being handed out to members as they arrived at the club and the winners being allowed to choose their own prizes.

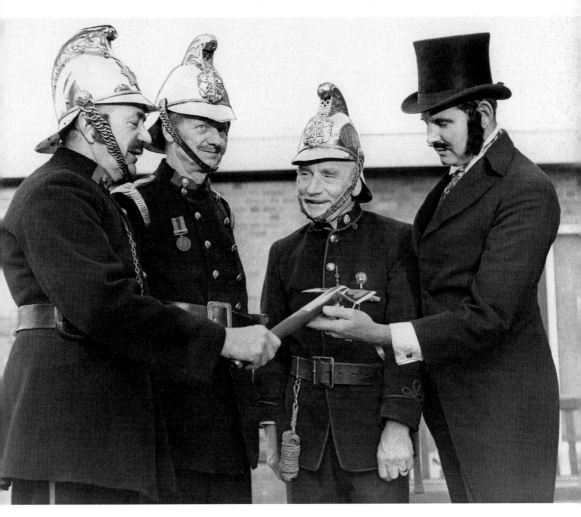

A grand night out was had by the audience of an Old Time Music Hall event which took place at the North Oxfordshire Technical College in April 1970. It was organised by Rotary and Lions members. The three former firemen pictured here wore the original uniforms of the Banbury Borough Fire Brigade, dating from 1890, 1906 and 1931. Fred Anker shows Divisional Office Harry Morgan (right) of the Oxfordshire County Fire Service the presentation axe given to his father. With them are former firemen Don Braggins and John Wilkes.

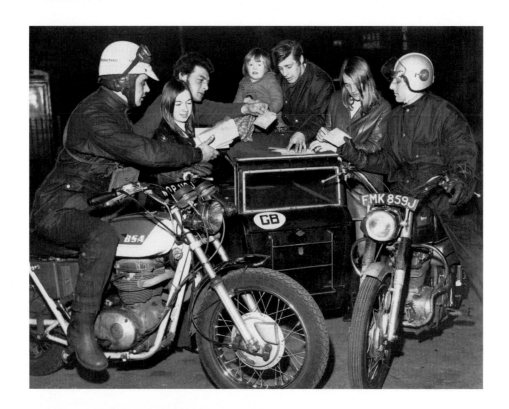

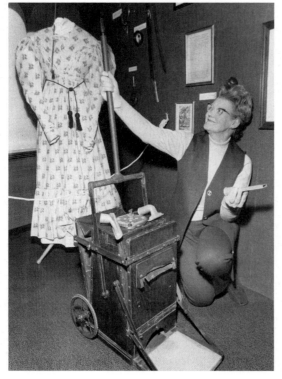

*Above:* In February 1971, when the postal strike was at its height, members of the Banbury Cross Motor Cycle Club took over the collection of urgent mail from Horton General Hospital each night and delivered it as far as Bicester and Woodford Halse. Friends and family of the bikers joined them in sorting the mail and ensuring that the hospital continued to function as efficiently as possible during the strike.

*Left:* An unusual event took place early in 1972 when an Edwardian vacuum cleaner arrived at Banbury Museum. Although in need of a suction tube, it was still in working order, using a bellows system which needed two people to operate it, one on the bellows, the other collecting the dirt with the tube. Shown with the new acquisition is museum assistant Mrs Millie Ford.

*Left:* Dancers from nine clubs descended on Banbury in November 1962 for an important Do-C-Do Square Dance Club night at Wincott's ballroom. The Banbury club was started to accommodate enthusiasts from the surrounding USAAF bases but they were soon outnumbered by local people. Two members of the club are pictured at the dance which went on until midnight.

*Below:* The MP for North Oxfordshire, Neil Marten, was one of the judges in the beauty contest held at the Horton General Hospital in February 1975. He is pictured with the top three winning contestants, winner Sandra Stanley, a nurse on the men's medical ward; Ponnitha Krishnasamy (right) who came second, and Nicky Baljeet who came third. Sitting on Sandra's knee is birthday girl, 5-year-old Jackie Doherty.

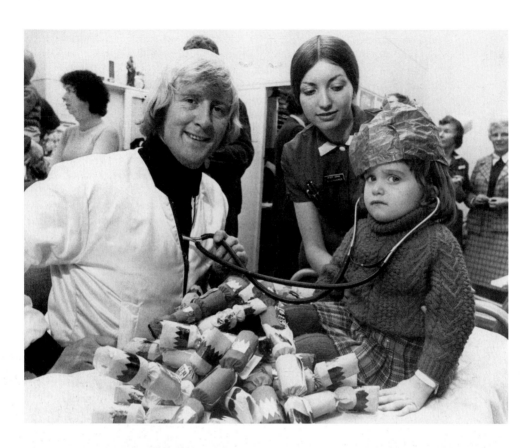

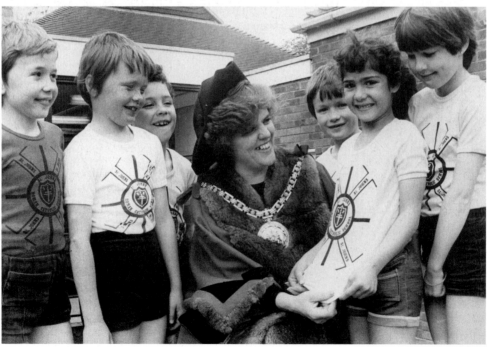

*Opposite above:* During his visit to Horton General Hospital in December 1978, Chris Tarrant had his chest listened to by 3-year-old Victoria Roberts of Colegrave Road, Bloxham, who was undergoing treatment for asthma. The presenter of the popular children's programme *Tiswas* visited the hospital to make a presentation of a portable television, donated by Bristol Street Motors, before going on to the Radcliffe Infirmary to hand over another television set.

*Opposite below:* Dress was the main topic of conversation when town Mayor Mrs Jayne Buzzard visited St John's School to show off the mayoral regalia in May 1981. She was accompanied by the Mace Bearer and Mayor's Sergeant Don Trafford, who told the children that the oldest mace dates from 1657, and the second from 1715. In 1823 Banbury town council went bankrupt and sold off the maces to the North family. The oldest one was given back in 1875 and the second one was bought back in 1923 by the town businessmen. The pupils are pictured showing Mrs Buzzard their own new outfits, T-shirts designed by senior pupil Alexander Lane.

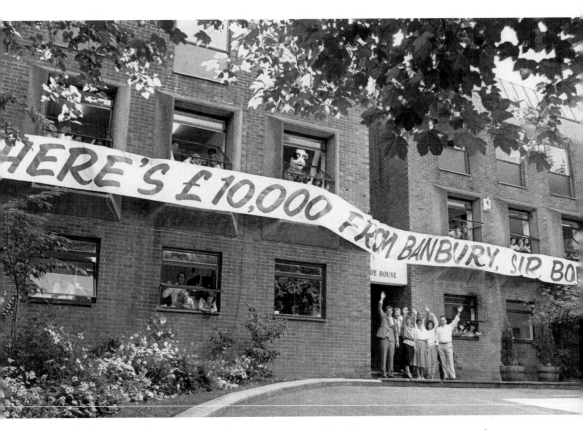

In July 1986 some 2,500 Banbury fun runners raised £10,000 to help the starving in Africa by taking part in a Sports Aid run. This banner, spread across the Banbury headquarters of Countrywide Communications which had sponsored the town's Run for the World, was a message to Sir Bob Geldof. Manager Peter Hehir estimated that at an additional £2,000 was still to come in.

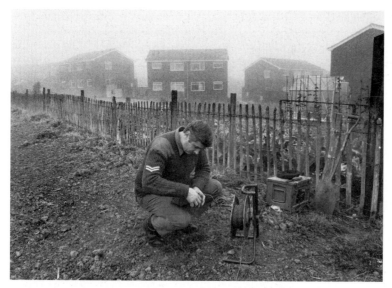

Mrs Rosemary Thornicroft and her family were walking across a field near their home in Tennyson Close in October 1977, when she found an unexploded mortar bomb. Bomb disposal experts from COD Kineton were called in and blew it up without incident. Corporal Gordon Drummond is shown about to detonate the bomb.

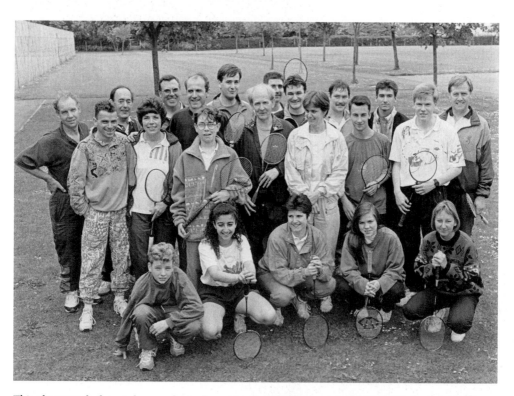

This photograph shows players who took part in a badminton match in May 1993 between Banbury and the town's French twin, the Paris suburb of Ermont. This twinning dates back to 1980, and since 1981 Banbury has also been twinned with Hennef in Germany. In their honour, Banbury has named roads Ermont Way and Hennef Way. In the Town Hall there is a Twinning Tapestry which commemorates the German twinning and shows aspects of life in both towns as well as Hennef's other twins, in France and Poland.

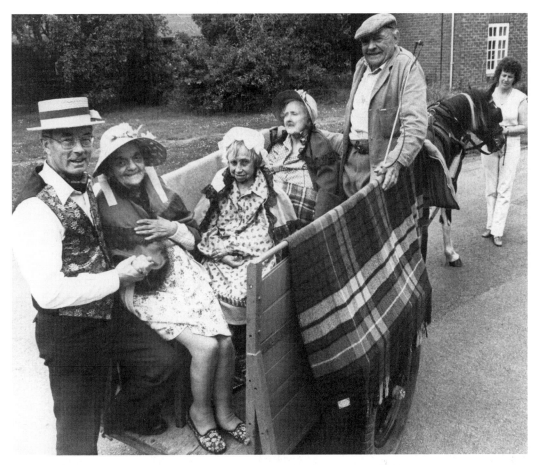

Banbury pensioners were taken on a drive down Memory Lane in July 1983. Hospital nurses swapped their uniforms for floral dresses and mob caps to fit in with the theme of turning the clock back. Mr Johnny Mould (76) poses with pensioners Mrs Lizzie Simms (88), Mrs Gladys Miles (78) and Miss Edith Jarvis, assisted by charge nurse Vincent Burns and Meg Wathen, who is holding Candy the pony.

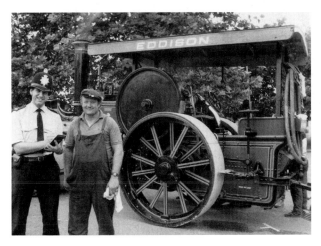

When steamroller driver Mike Berry was spotted with a police escort in August 1987, jokes were made about his having been booked for exceeding the speed limit. The steamroller arrived in the police station car park and took up three spaces. 'Sally', built in 1922, was there to take part in a fête and car boot sale at the Orchard Lodge senior citizens' home next door. The steamroller, which was owned by the Edison road-laying company, operated between the Brecon Beacons and Swansea. Pictured here are Mike Berry and PC Neil Dyson.

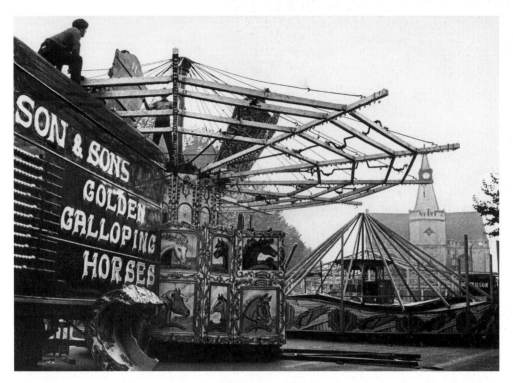

One of the main annual events in most market towns is the autumn fair. In 1952, one of the oldest and most popular rides was the Galloping Horses, which is being erected in this photograph. The three-day Banbury Michaelmas Fair (held in October) is the survivor of a number of fairs which were included in the town's Charter. The modern event has evolved from a 'great hiring fair' which used to be held on the first Thursday after Old Michaelmas Day, 10 October.

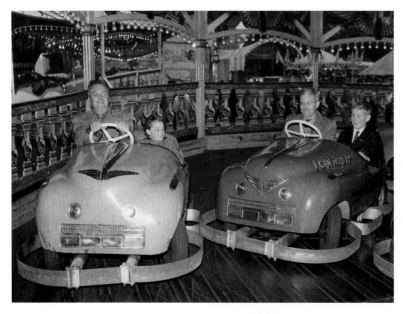

Bumper cars were as popular in 1957 as they are today. There is ongoing controversy concerning the disruption the fairs cause to everyday life in the town by obstructing the streets and creating noise and litter. Others point out that they are traditional and, in any case, only last a couple of days.

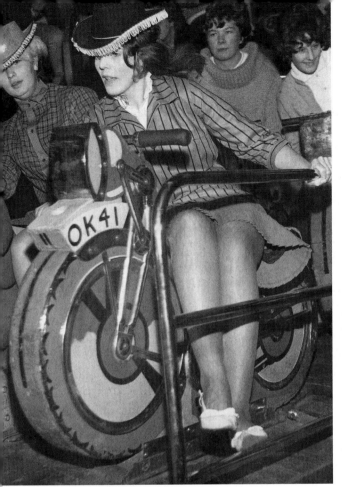

In the early 1960s it was suggested that the Banbury Michaelmas Fair should be moved out of the centre and relocated to a site outside the town. One mother interviewed said that 'if the council shifted it outside the town we should still go. It isn't the siting that counts but the enjoyment and thrills that the kids get.' These girls, pictured in October 1963, look ready and willing to go to the fair, wherever it is situated.

In 1964, there was no doubt in the mind of those who went to the fair that the traditional approach was the best. Crowds flocked into the centre to enjoy the atmosphere, as demonstrated by these girls riding on the Waltzer. For once, the big wheel was missing, having been replaced by the Paratrooper.

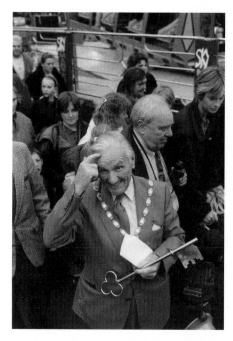

*Left:* The opening of the Michaelmas Fair by the Chairman of Cherwell District Council, Ron Groves, in October 1995. The photograph captures the moment just after Mr Groves had accepted the gold key from William Wilson, of Bob Wilson Funfairs Limited, the fair-holder. Mr Groves then toured the fair for an hour, during which time rides he touched with the key were free for the many youngsters following him.

*Below:* These two shop assistants, pictured in December 1966, are Mrs Gwen Green of Bodicote and Mrs Bertha Grant of Banbury. The ladies are taking advantage of an unusually quiet period during rush of pre-Christmas shopping. The artificial Christmas tree is being given a tweak to spruce it up, and a fresh pile of Sindy doll accessories are being put out for eager customers.

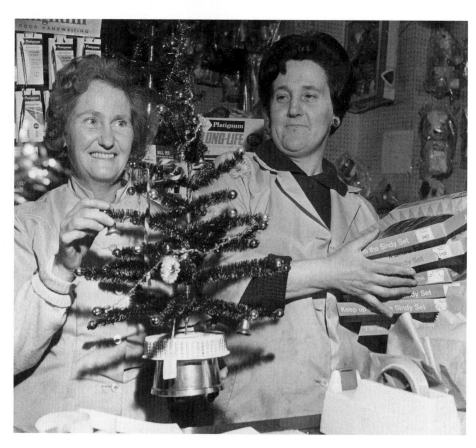

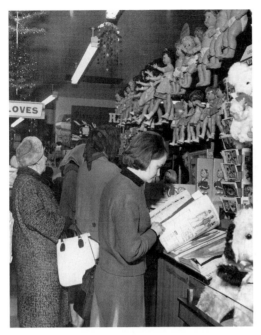

*Left:* Christmas shopping in Banbury, 1967. This photograph shows the mixed selection of goods which were offered for sale in a very confined space, from baby dolls to postcards, shaggy dogs to gloves. The lady in the foreground is choosing a paper pattern from the high-busted mini-skirted range which was fashionable at the time.

*Below:* Madame Krassowska-Jodlowska, Vice-Minister for Higher Education in Poland, went on a tour of English colleges in March 1965. She is shown here discussing hairdressing with a group of students of the North Oxfordshire Technical College, and said, through an interpreter, 'I must come back to Banbury and try some of your hair styling.'

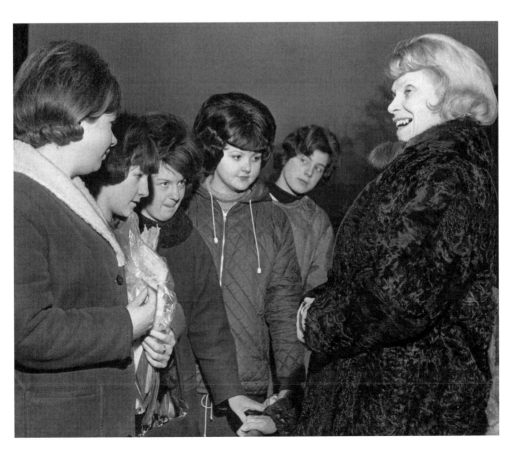

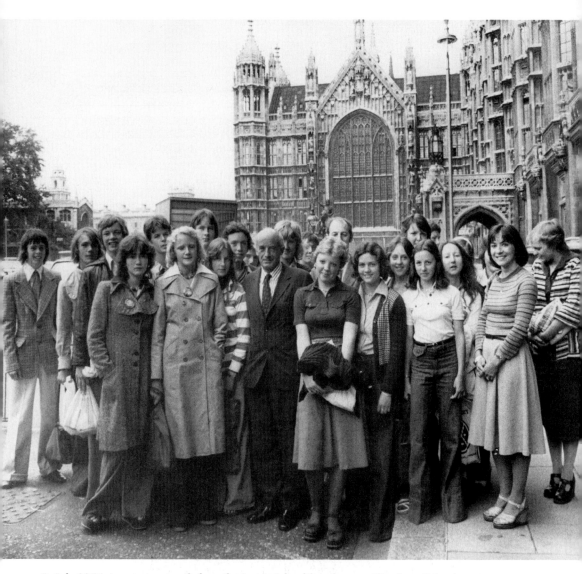

In July 1976, twenty-two pupils from the Lower School fourth year at Banbury School went up
to London to see a session of *Question Time*. They were the guests of Neil Marten, MP for North
Oxfordshire, who arranged the visit and is pictured with them in the centre of this photograph taken
outside the House of Commons.

# ❦ 3 ❧

# INNS AND PUBS

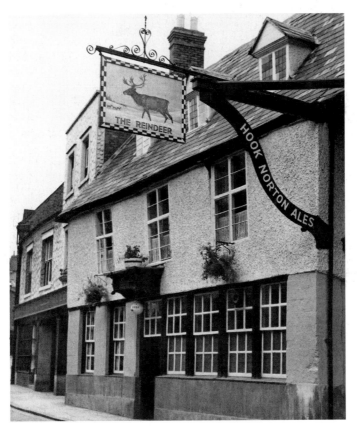

The exterior of Banbury's oldest and best known pub, the Reindeer
Inn (sometimes called Ye Olde Reindeer) in Parsons Street,
photographed in March 1960. It's Globe Room acted as a meeting
place for Parliamentarians during the Civil War and Cromwell is
said to have used the room while he worked out his strategy for the
battle of Edge Hill in 1642. He is also said to have stayed there while
laying siege to Banbury castle. The inn, which has doors bearing
the inscription *Anno Din 1570*, is one of the main features on the
Banbury Historic Town Trail.

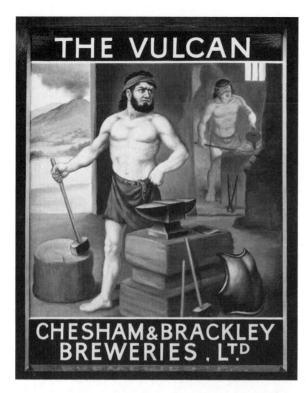

In September 1956 the *Oxford Mail* reported on this newly designed inn sign, which had recently been painted for The Vulcan on Foundry Bridge. The sign, which was produced locally at the Thame studios of artist and sign-writer Stan Court, shows the muscular Roman God of Fire posing with an erupting volcano in the background.

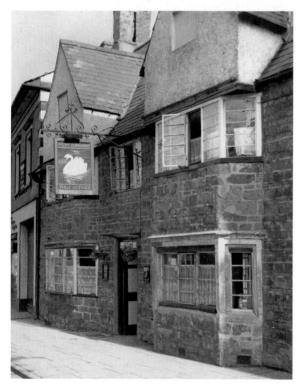

The reporter who wrote the article to accompany this photograph of the White Swan in South Bar, taken in October 1957, described the racket which met his ears on entering as 'the sort of noise that I associate with the final stages of a Farmers' Union, or regimental reunion, dinner.' However, as the landlord, Arthur Essex, told him, it was 'just a quiet game of crib.'

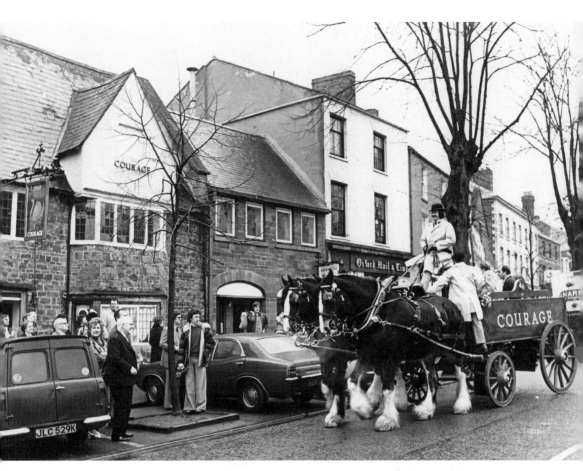

The White Swan (along with the Horse and Jockey at Bodicote) was one of the two premises exchanged between brewers Mitchell and Butler, and Courage. This dray, about to make a delivery to the pub in February 1978, was made by Jimmy and Barney, two shire horses from the Courage Dray Horse Stables at Maidenhead. After the horses were refreshed with a pint each by landlord Frank Ginger, they set off for a tour of the town with the dray wagon full of locals.

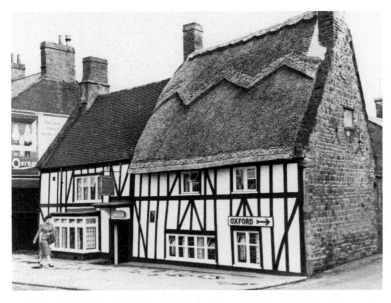

In this photograph, taken in October 1957, the newly thatched Three Pigeons in Southam Road looks like a dolls' pub. Situated at a crossroads on the busy route between Oxford and Coventry, what was once a quiet pub on the outskirts of Banbury has now become a town-centre venue. Today, three pigeons have been worked into the design of the present thatched roof.

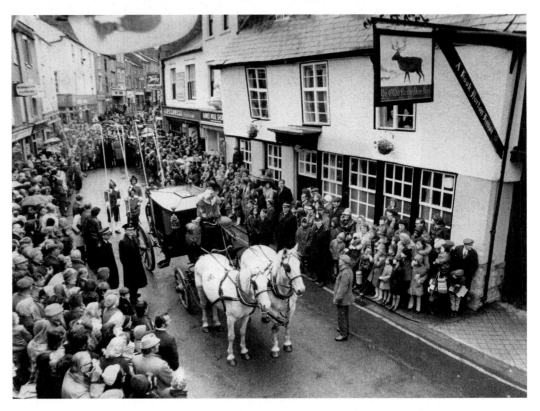

In May 1972 Parsons Street was packed with onlookers as a procession of Fairfax's Parliamentarians, played by members of the Sealed Knot Society, made their way to the Olde Reindeer to mark its reopening, which had just been completely rebuilt by the brewery. The coach, drawn by a pair of greys, had been used in the film *Cromwell*.

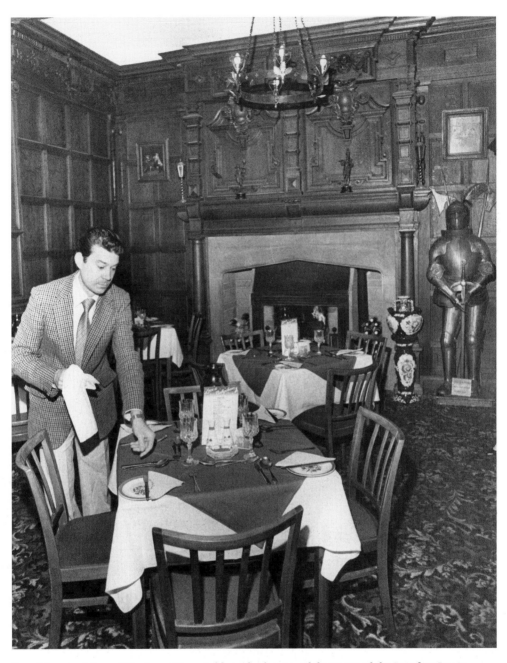

Proud licensee Manuel Riveiro setting a table in the famous Globe Room of the Reindeer Inn in October 1982. When it was proposed to demolish the Globe Room and sell off the impressive seventeenth-century ceiling and panelling there was a storm of protest but the town council refused to buy it. It was taken off to London but the sale was never completed. It remained in London where the ceiling was destroyed in the Blitz, the remainder being moved to Islington in 1963. The following year, when Banbury Historical Society contacted the Victoria and Albert Museum to find out its whereabouts, they were told that the panelling had been offered to them the month before. This time the Borough Council bought them and it was reinstalled in the Globe Room.

*Left:* When the White Horse in the High Street was being demolished in the summer of 1961, the foreman in charge, Mr J. Chapman, came across an eighteenth-century coin on the ground floor. It was a spade guinea dated 1790. These coins got their names from the fact that on the reverse they had a shield shaped like a spade. They were issued between 1787 and 1799 but were discontinued when war with France inflated the price of gold. Imitation spade guineas were used as gaming tokens.

*Below:* The Windsor Castle in Lower Windsor Street was yet another casualty of the redevelopment programme. It was a sad time for licensees Mr and Mrs W.J. Young whose home it had been for several years. They are pictured in March 1962 with regulars and their daughter, as last orders were about to be called for the final time.

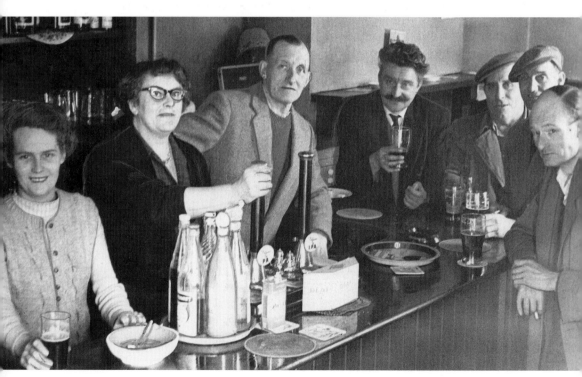

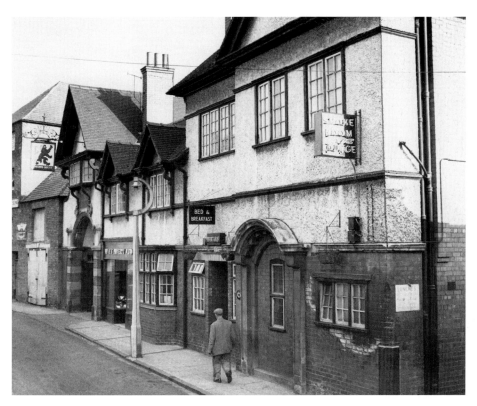

This is the Red Lion in High Street as it appeared in July 1962 when it offered overnight accommodation and lunches. Ninety years previously it was listed in the 1852 edition of Gardner's Directory as a Commercial Inn and Posting Office. Banbury's Lion inns and pubs are confusing as apart from the Red Lion they have included the Red Lion Tap in Fish Street, the White Lion in High Street, the Golden Lion at Grimsbury and the Lion at Nethercot.

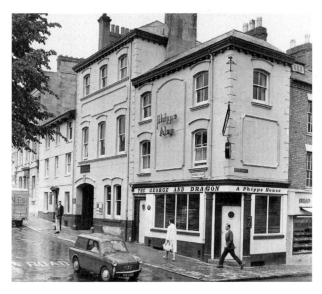

This is the exterior of what was described as a 'famous public house site' in July 1963. This was the George and Dragon in Horse Fair, which, according to the *Oxford Mail*, was 'one of the most valuable sites in the town - by The Cross.' Application had recently been made to Oxfordshire County Council by Watney Mann Property Co. Ltd to build a supermarket there.

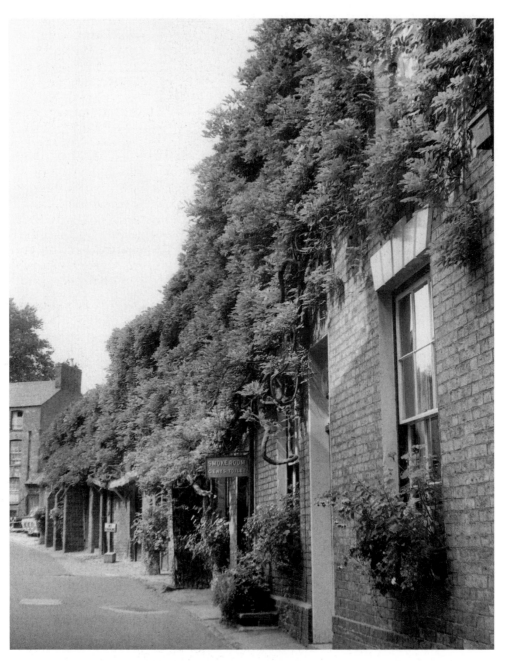

The best known of all the Lion pubs and listed on the Banbury Historic Town Trail is the White Lion in the High Street, which was a coaching inn in the nineteenth century. For decades it has been known for its enormous wisteria, which at one time ran right along one of its walls. The 250-year-old wisteria at the White Lion, at that time said to be the largest in the country, was reported to be in danger in August 1965. The iron rod which supported the 150ft-long tree had worked its way out of the masonry, slipped 8 inches, and damaged the cement which was 'bandaging' cracks in the branches. Wooden and metal props were installed immediately and the patient was said to be as well as could be expected under the circumstances.

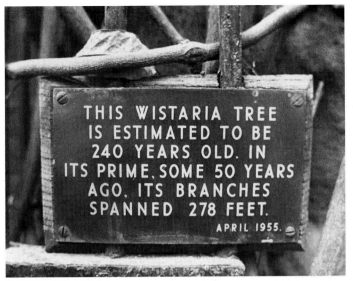

THIS WISTARIA TREE
IS ESTIMATED TO BE
240 YEARS OLD. IN
ITS PRIME, SOME 50 YEARS
AGO, ITS BRANCHES
SPANNED 278 FEET.

APRIL 1955.

In April 1976 the wisteria was back in the news when the *Oxford Mail* carried a report that some 40ft had snapped off of it. A thousand pounds had been spent on preserving it, and Michael Gorch, the architect of White Lion Walk development, called it a tragedy. This plaque, dated 1955, describes the tree as it was in its prime. However, it is good to relate that the 2009 edition of the Town Trail mentions a 'Fine wisteria in rear yard which once led to stables.'

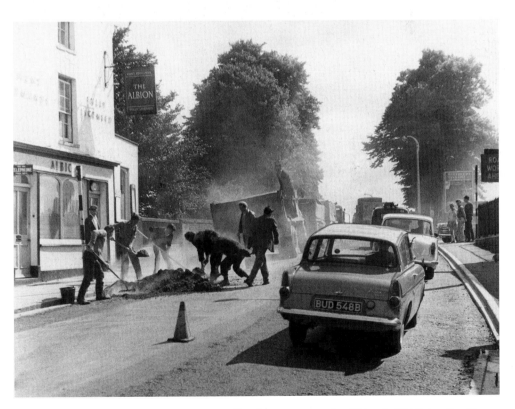

It must have been very unpleasant for the staff and customers at the Albion in Middleton Road in 1965. Apart from the noise, smell and dirt, they had to put up with queues of traffic outside their door as contractors to Oxford County Council and Banbury Borough Council resurfaced the nearby railway bridge. The rebuilding of the bridge, carrying all east-west bound traffic over the main Birmingham-Paddington rail line, took six months to complete.

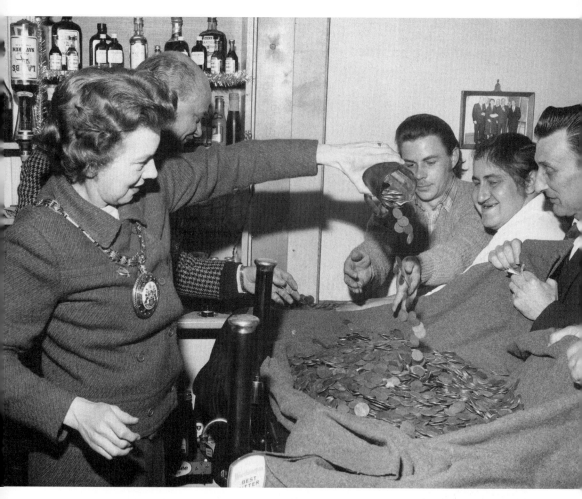

Banbury's Mayor, Councillor Mrs Patricia Colegrave, is shown sending a cascade of coins into a blanket in the Jolly Weavers in March 1968. For seven years, customers of the pub in South Bar had been constructing a pile of pennies, reinforced with silver and the odd £1 note. When it reached 3ft, the licensees, Harry and Florrie Handy, decided it was demolition time and chose to give the cash to Sycamore House, 'a hostel for mentally-handicapped children'. Counting and washing the coins, which totalled nearly £50, went on long after closing time.

*Opposite above:* These old shuttles and bobbins were on display in the Jolly Weavers when it reopened in November 1976. They were a reminder to twentieth-century drinkers that the pub had been the headquarters of the wool weavers of Banbury around three centuries before. The refurbishment cost the landlord, Manuel Riveiro, £9,000. Pictured with him are Bob Clement (right), area manager for Mitchell and Butler's, and head waiter of the adjoining restaurant, Luiz Mendez (centre).

*Opposite below:* The exterior of the Cricketers Inn, Middleton Road, is pictured here in October 1970. This working-class pub survived the various rebuilding programmes of the twentieth century. Living up to its status of an inn, it continues to provide guest rooms and hosts the monthly meetings of the Banbury branch of the Royal Enfield Owners' Club.

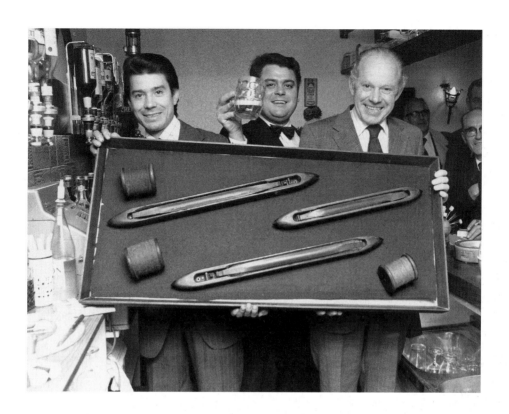

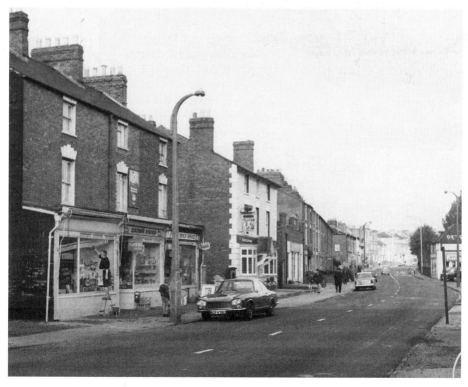

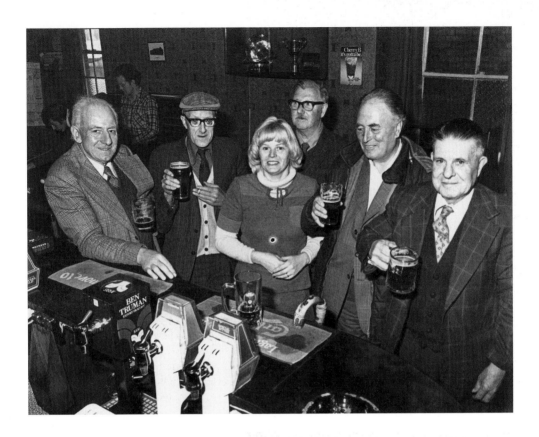

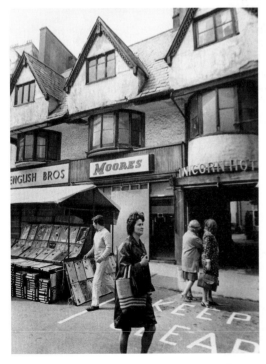

*Above:* Between them, six customers of the Cricketers Arms in Grimsbury notched up 300 years of drinking. Pictured with landlady Eveline Jones in October 1977 are, from left to right, Chris Wiggins (59), head gardener at Alcan Booth; Sam Young (62) of the Whately Hall Hotel, Alf Parish (61), another Alcan worker; Jim Hobbs (69), a retired inspector with Midland Red buses; and Jack Barson (68), a British Rail worker for forty-six years. The sixth member of the group, farm manager Cyril Wilkins, declined to be in the photograph.

*Left:* The Unicorn Hotel in the Market Place is seen here in May 1971 when it was the subject of a demolition proposal. The original building included this three-gabled range, the entrance to which is through the archway and past a gateway with the date 1648, which is probably the date of the building. A leading Banbury inn in Stuart times, the Unicorn is best known today for its Liquid Lounge.

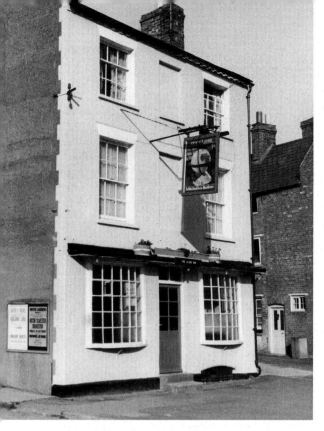

The exterior of the Globe Inn in Calthorpe Street, November 1971. This elegant Grade II-listed building escaped the fate of many other pubs in the town centre. It has since been divided up in order to house a number of offices, one of which was for a time a branch of Bonham's, the prestigious fine art auctioneers.

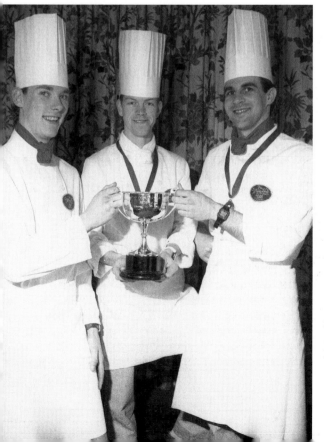

Situated in the Horse Fair, near the Cross, the Whately Hall Hotel (formerly known as the Three Tuns Inn) is one of Banbury's most prominent buildings. Despite general refurbishment, original features such as concealed staircases, wooden beams, stone fireplaces, priest holes and even the resident ghost known as Father Bernard have been retained. In November 1990, four chefs from the Whately Hall Hotel beat eighty other exhibitors to scoop awards at the Caterex exhibition in Cowley. Pictured here are three of the winners, from left to right, Rook Gouldie from Bicester, Adrian Spelman of Victoria Place, Banbury, and Michel Olivier from France.

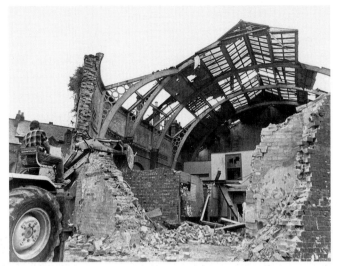

When this photograph was taken in July 1973, more than half of the demolition work on the site of the new shopping centre to the north of the Market Place had been completed. The old Vine public house in Cornhill is shown being reduced to a pile of rubble. A pensioner from Bodicote was spotted among the debris searching for a new lavatory pan. He explained, 'I dropped a hammer on mine yesterday and cracked it. I thought I mind find one among this lot.'

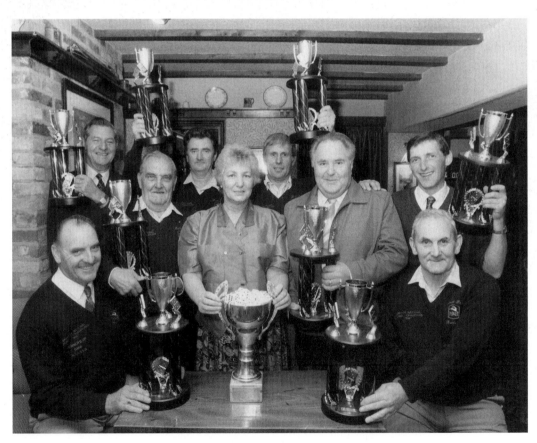

Celebrations were the order of the day in October 1991 at the Bell Inn in Middleton Road when the pub succeeded in the Domino Championship. Pictured with an astonishing array of silverware are from left to right, back: Tom Sharman, John Potter, Keith Brown and Jamie Phipps. Front: Ron Coles, Leslie Andrews (captain), Liz Potter, John Sharman and Arthur Wilkins.

# ❦ 4 ❧
# BANBURY AT WORK

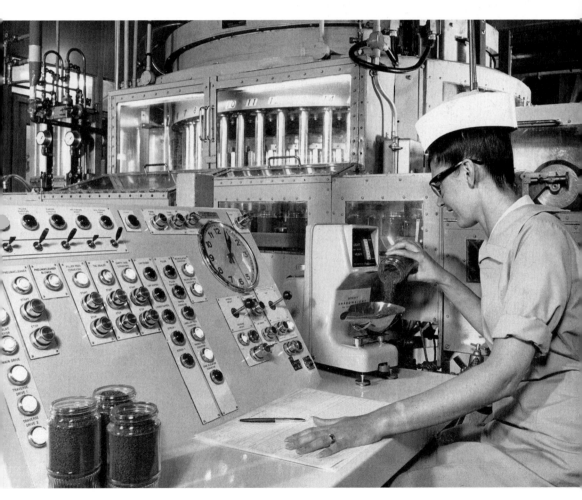

On to February 1971, and another array of space-age levers and dials, complete with *Joe Ninety* hat and goggles for the operator to wear. In this case it is a device at General Foods designed to carry out a spot weight check on the contents of these jars of coffee which had been filled by machine. Leading brands of coffee produced there were Maxwell House and Bird's Mellow.

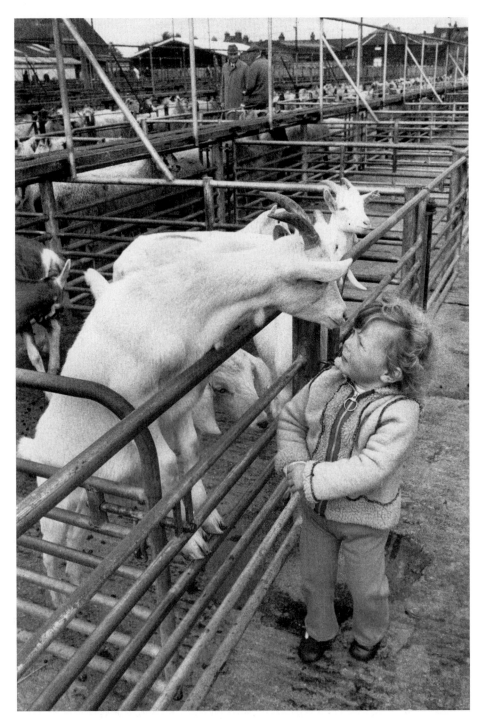

The livestock at Banbury Stockyard was not confined to cattle, as 2-year-old Cassandra Brown found out to her surprise when she was greeted by a nanny goat which insisted on sniffing her thoroughly. Pictured here in October 1977, Cassandra seems unable to decide whether to run away or stay and make friends.

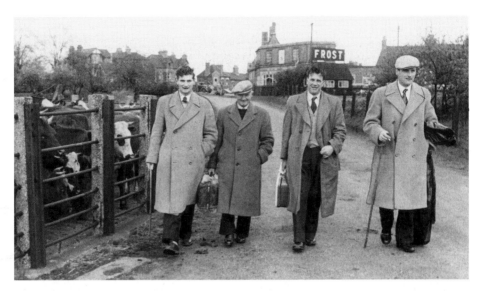

Banbury once had several street names connected with the sale of animals and still has its Horse Fair. So respected was the reputation of Banbury's livestock market that it drew buyers from far and wide. Shown here in May 1954 are cattle dealers H. Purcell, E.J. Moore, P. Dillon and S. Purcell on their arrival in Banbury on one of their fortnightly trips from Ireland.

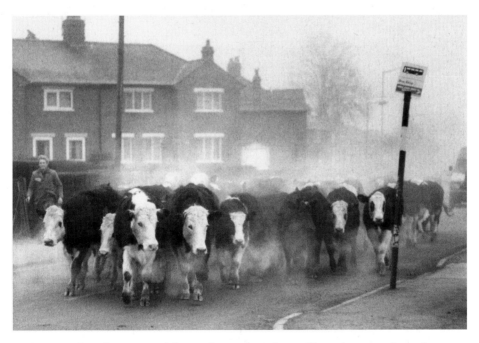

Banbury Stockyard was Europe's largest livestock market and brought prosperity to the town. This was a mixed blessing, however, as the residents of the area surrounding the market found to their cost every Wednesday and Thursday when lorries and their contents took over the streets. This photograph, taken in March 1985, clearly illustrates why locals said the scenes were like something out of the television series *Rawhide*.

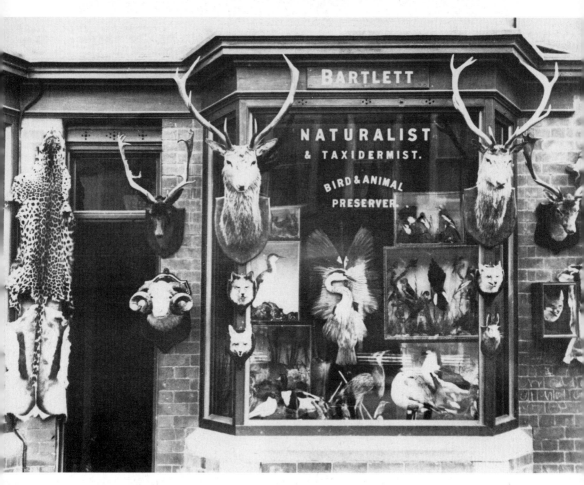

More livestock, but this time more exotic and definitely less lively. Mr Bartlett, whose taxidermist's shop was at 24 High Street, was also an accomplished amateur photographer and it was he who took this undated picture. He also captured many Banbury events from the window of his living accommodation above the shop.

*Opposite above:* General markets have been held in Banbury since the twelfth century, the present one being granted by royal charter of Henry II. This jewellery and gift stall, lit by hurricane lamps, looks set to do good business as Christmas shoppers throng around in mid-November 1967. The metallic purse looks almost good enough to eat!

*Opposite below:* The market is shown on August Bank Holiday 1974. The newspaper report accompanying the photograph stated that the Market Place would 'soon be enhanced as a shopping centre by the new shopping precinct being built on its northern side by the Cherwell District Council,' thus combining the ancient with the modern.

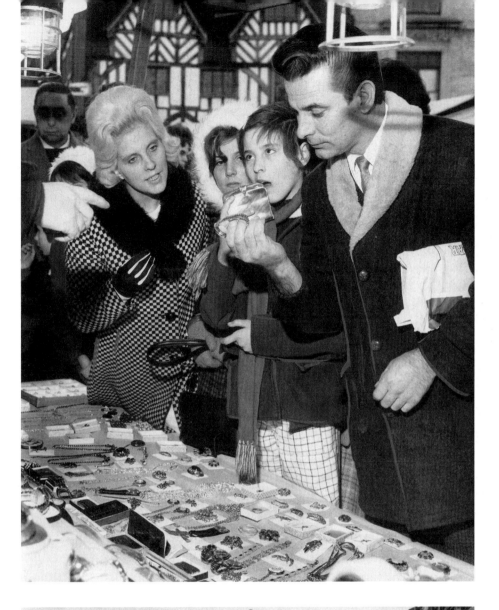

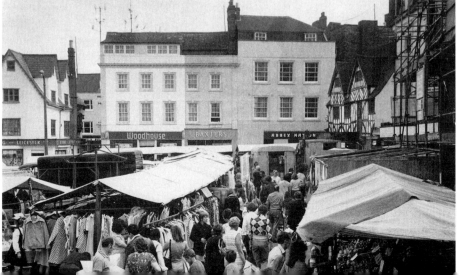

65

In November 1971 prospects looked good for Banbury shopkeepers as a bumper spending spree was predicted. The record year was put down to a determination to forget about unemployment figures and have a traditional Christmas blow-out. The market traders were also included in the shopping spree as early Christmas shoppers looked for bargains among the stalls.

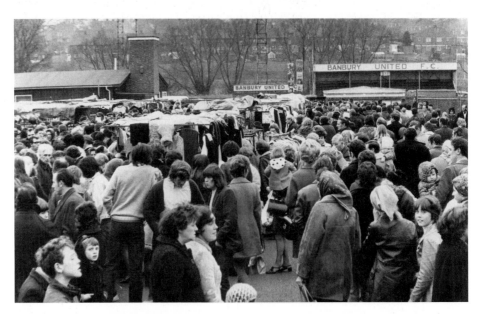

The town's first Sunday market brought traffic to a stand-still as thousands of shoppers headed towards Banbury United Football Club's ground, where nearly 200 stalls promised Christmas bargains in December 1971. The police had their work cut out controlling the long traffic queues which stretched along High Street, Middleton Road and Castle Street.

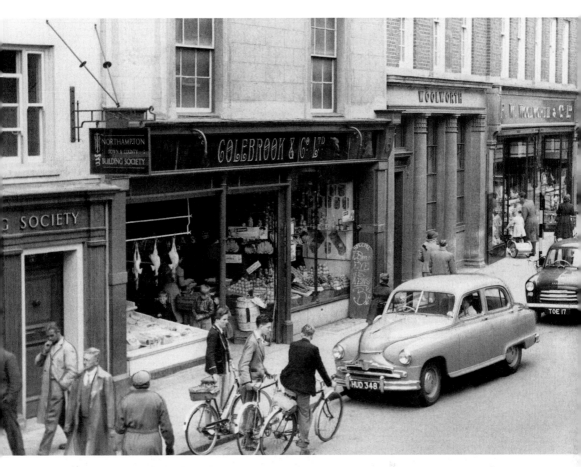

Shops are of course the mainstay of any town's retail trade but, as elsewhere, Banbury has lost a significant number of individually-owned shops to chain stores. This photograph of Colebrook's at No. 6 High Street, itself one of twenty-two branches, was taken in June 1956 shortly before the premises were acquired by F.W. Woolworth & Co. This extended Woolworth's shop had already moved into the former National Provincial Bank in 1952.

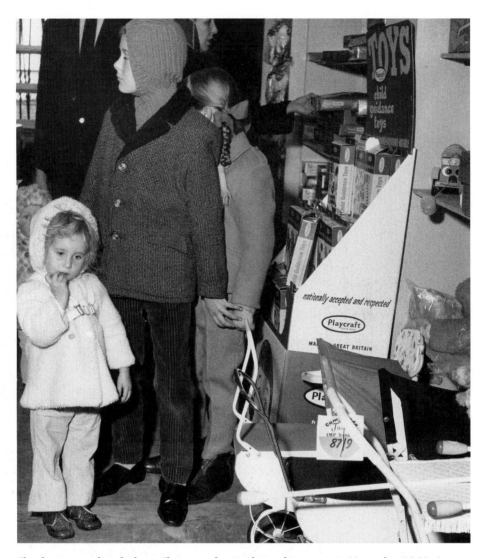

Shopkeepers predicted a busy Christmas despite the credit squeeze in November 1969. At this time Banbury was one of the busiest shopping centres in the South Midlands, with the population of 27,000 estimated to increase to 41,000 by 1981. The price of the doll's pram in the photograph would be about £4.37p in today's money.

*Opposite above:* In 1968 Banbury Chamber of Commerce decided against putting up Christmas lights in the town but the shops made up for it. In this confectioner's on South Bar, Mrs Hilda Simpson is pictured decorating the tree with chocolate ornaments while Mrs Heather Stewart hangs up Christmas stockings and sweet-filled Santas.

*Opposite below:* In the spring of 1972, Mrs Florence Tysoe organised a petition to save her newspaper and bookshop from closing. Mrs Tysoe had sold papers at the station for nineteen years but had been told by British Rail that the shop was to close that April, after which papers were to be sold in the refreshment room which opened at about 9.30 a.m. This meant that passengers catching early trains had to go without their morning papers, to the 'disgust' of many.

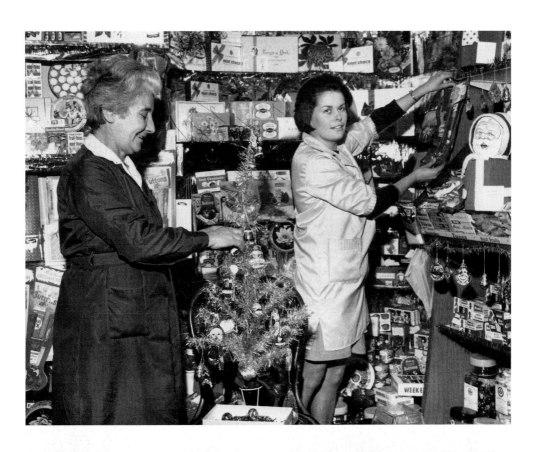

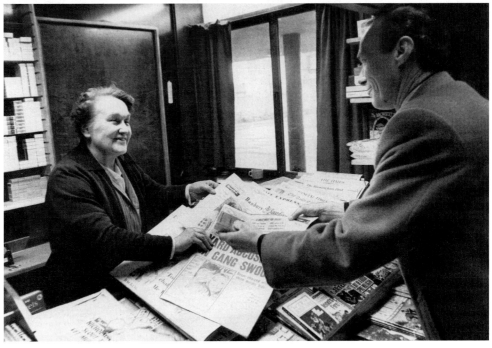

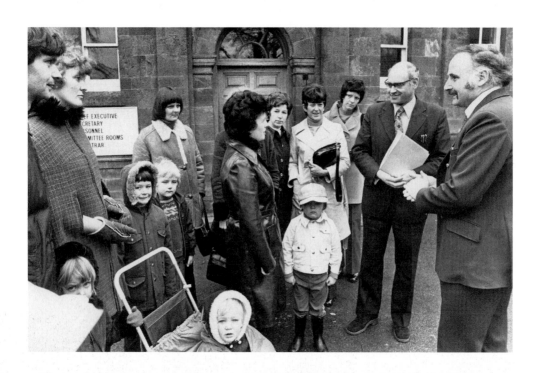

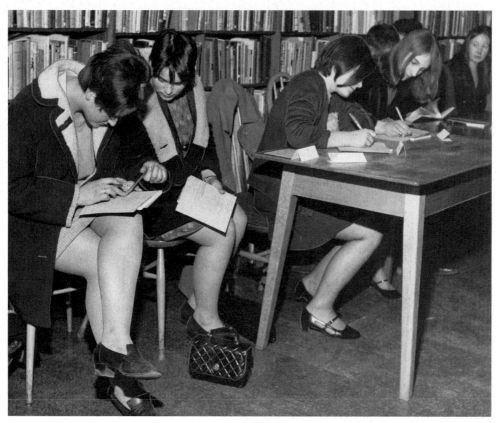

*Opposite above:* In January 1975 Anthony Brace (second from the right), Cherwell District Council's Chief Executive Officer, was presented with a petition by Colin Taylor (right), Vice-Chair of Cherwell Heights Residents' Association. Nearly 700 residents were demanding a general store, chemist and newsagent for the estate instead of the further homes which had already been approved.

*Opposite below:* The standard of service in shops in the Banbury area was expected to rise after these girls completed their course in retail distribution. More than forty students enrolled in January 1968 for the course at the North Oxfordshire Technical College and School of Art. Apart from making sure that both trader and customer benefited by their tuition, it was hoped that the course would raise the status of shop work and turn it into a career.

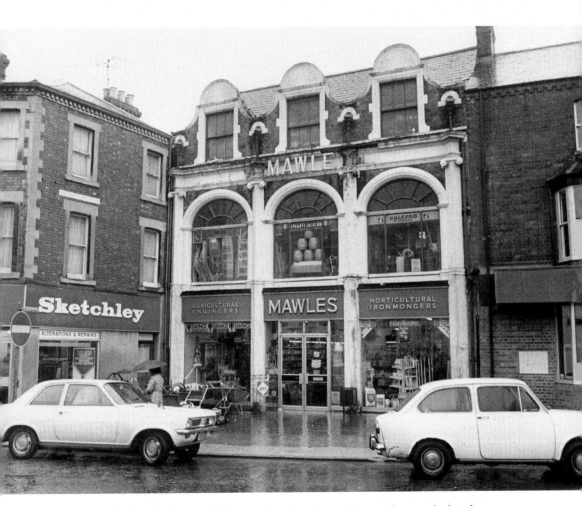

A Banbury landmark closed in 1977, a victim of parking problems. This was the handsome ironmongery shop of J. Mawle & Sons Ltd at No. 22 High Street, which had been in business in Banbury since the end of the nineteenth century. Mawle's agricultural engineering works in George Street closed at the same time, with a total loss of thirty-one jobs.

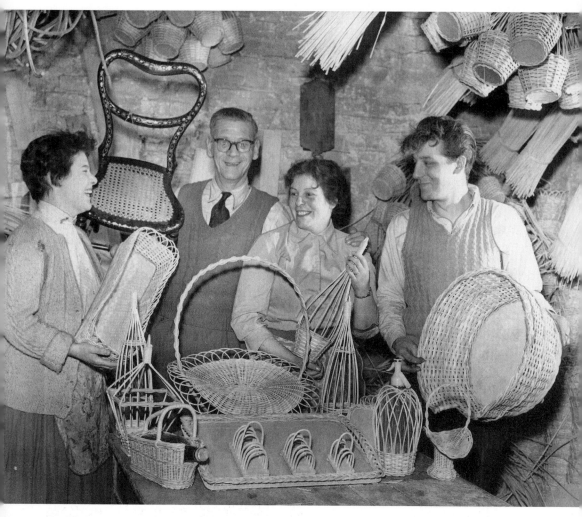

This photograph, taken in April 1959, shows a group of people very happy in their work. They are David Ross, his wife, son and daughter. Their workplace was an upper room at 20c Castle Street, where, with assistant Barbara Harvey, they made cane goods. There was, said Mr Ross, an increasing demand for bottle holders, with the five-strong team producing an average of thirty-six of them an hour.

*Opposite above:* This was one of the few industrial scenes to be found in Oxfordshire when this photograph was taken in the 1950s. It neatly links old and new for it shows the clean and modern Banbury Aluminium Works in the centre background while nearer the camera a coal-burning working barge makes its way along the canal, towed by a leisurely barge horse, complete with nose-bag.

*Opposite below:* This scene of general desolation in January 1971 shows Alps' old works awaiting demolition prior to the construction of the sports complex in Spiceball Park. On the other side of the works is Lamprey's Mill, which was converted into the Mill arts and education centre. John Lamprey is listed as a corn merchant in Gardner's Oxfordshire Directory for 1852.

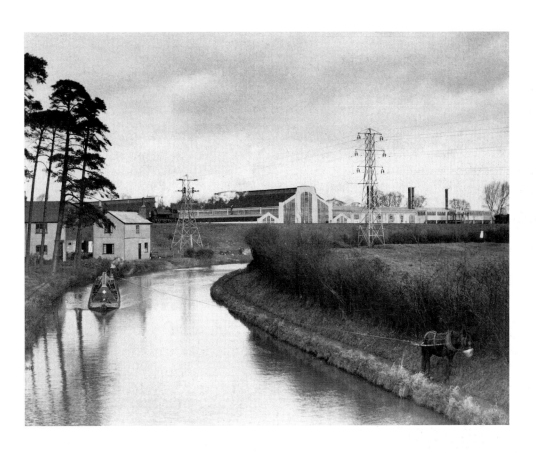

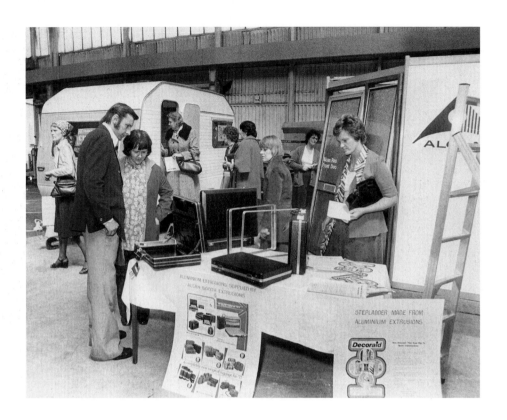

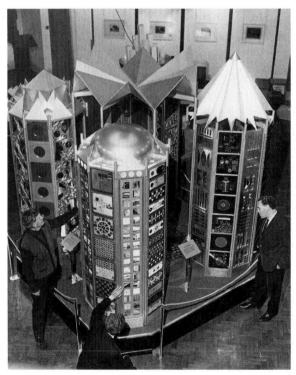

*Above:* An open day at Alcan Booth Extrusions in May 1977 attracted some 1,200 visitors, including the town mayor. Visitors were able to tour the factory and take part in a free raffle for an aluminium greenhouse. The turnout delighted the company, who planned to make it an annual event.

*Left:* This 1970 showpiece of Alcan Booth Industries Ltd was said by some to resemble the Roman Catholic Cathedral in Liverpool, while others found it more like something constructed for space travel. It is in reality a pavilion containing pictures and examples of the many uses to which aluminium could be put, and was designed by William Mitchell who did in fact design the south face of the cathedral.

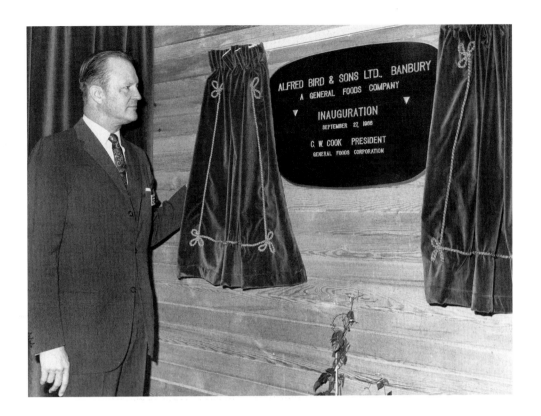

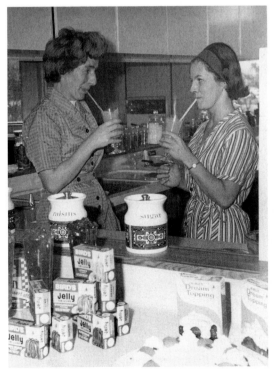

*Above:* General Foods were another leading employer in Banbury. Shown in September 1966 unveiling a plaque to commemorate the opening of subsidiary company Alfred Bird & Son Ltd's new £7 million factory in Banbury, is C.W. Cook, President of the General Foods Corporation of America. The plaque was designed and made for Bird's by neighbouring factory Aluminium Laboratories Ltd.

*Left:* The principal reason for Bird's move to Banbury was the opportunity to expand. In 1966 the company employed 1,350 people locally and expected to create many more jobs. Pictured trying out one of the company's new products that September are home economist Miss Margaret Slann (right) and her assistant Mrs Eva Stevens. The two ladies tried out every new product to make sure that the housewife 'could use Bird's products easily and efficiently.'

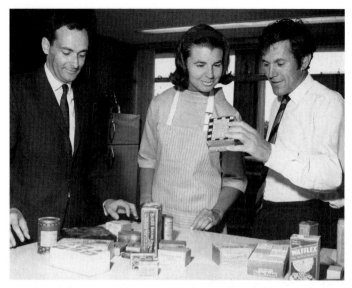

In August 1969 a large cardboard box containing Bird's products, dating from as early as 1843, was discovered during a clearing-up campaign. Home economist Joy Needham and technologist Clive Waterman are pictured here examining some of the products, in this case baking powder packed during the First World War. Other treasures were canned peas, baking custard, egg substitute, ginger beer powder and cake mix.

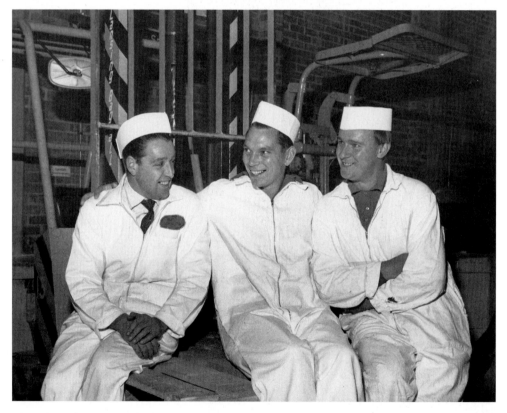

These three men, Tony Gossage, Terry Morris and Peter Turner, took the first three places in the General Foods annual competition for forklift truck drivers held in October 1967. There won £25, £15 and £5 respectively, and went on to represent General Foods in a nationwide contest, but on that occasion were unplaced.

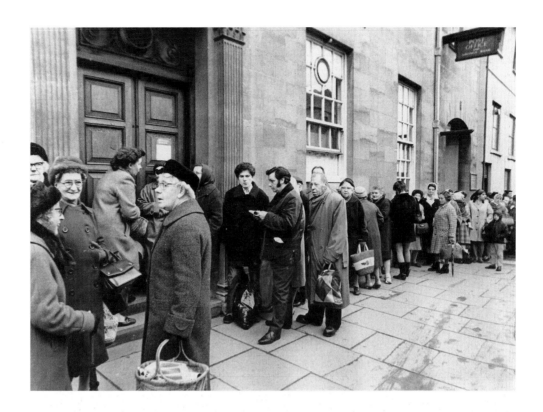

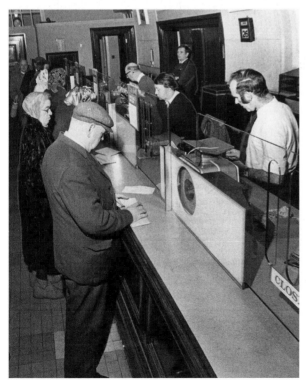

*Above:* Part of the 100-yard-long queue outside Banbury post office in January 1971 as the postal workers' strike entered its second week. Volunteers manned the counters in order that pensions and other allowances could be paid out. Later a post office spokesman stated that everyone in the queue had been served.

*Left:* These Banbury residents were able to collect their pensions at the post office during the postal workers' strike, however, although these volunteers opened the tills for a short time, strikers had decided to withdraw their round-the-clock manning of the emergency telephone system at the exchange, and only two men were on duty at night.

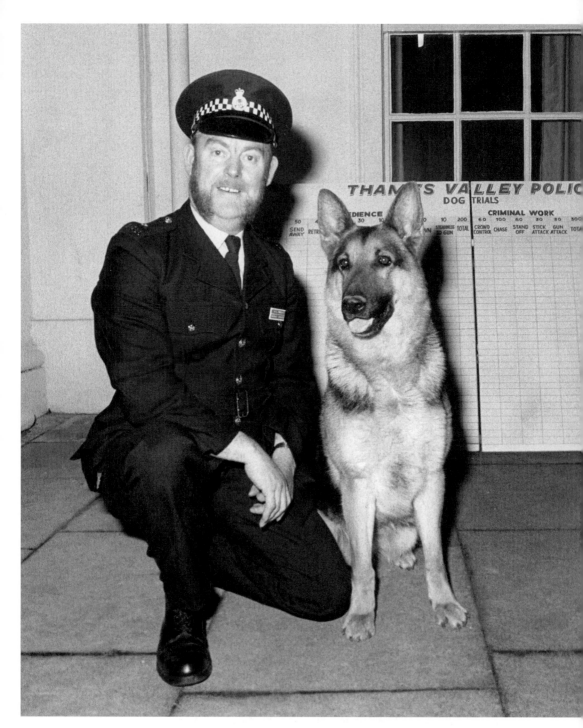

A pair of very important workers in the news in September 1980 was 4-year-old police dog, Flash, and his handler PC Ray Burley. In addition to winning several awards, Flash was nominated Police Dog of the Year for tackling a man armed with a carving knife in Banbury. Flash was a late-comer to dog training as he did not start until he was two years old.

## ❧ 5 ❧

# CHURCH AND CHAPEL

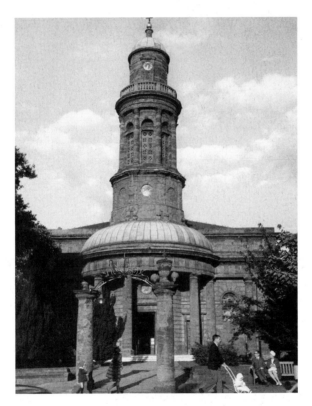

The rather unprepossessing façade of the parish church
of St Mary the Virgin, photographed in August 1968,
gives little hint of the elegance of the interior. The existing
church, said to have been modelled on Sir Christopher
Wren's St Stephen Walbrook, replaced a medieval one
which had been allowed to decay and as a result became
dangerous. The final straw was the collapse of part of
the fabric, followed by the tower, in April 1790. The new
church, which contains a few relics of its predecessor, was
consecrated in September 1797, although its distinctive
tower was not finished until 1822.

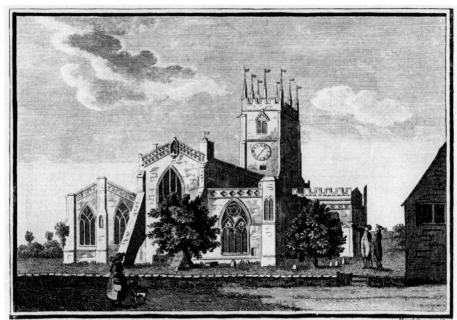

BANBURY CHURCH, *in* OXFORDSHIRE.

Published according to Act of Parliament by Alex.r Hogg, N.o16 Paternoster Row.

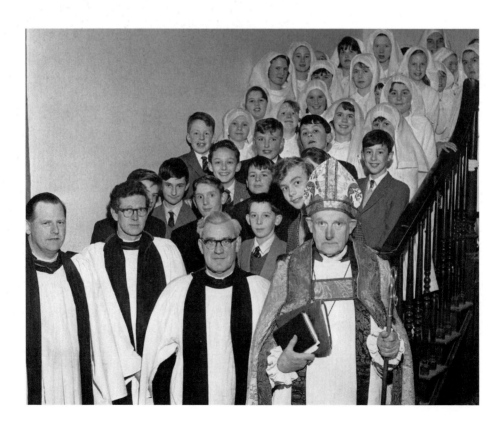

*Opposite above:* The fine medieval parish church, which a proud parishioner is showing to a visitor, is the subject of this eighteenth-century etching. The fact that it was initially allowed to fall into disrepair and finally blown up with gunpowder, has contributed to the people of Banbury's former reputation for being inclined towards vandalism.

*Opposite below:* These thirty-five youngsters were confirmed by the Bishop of Dorchester, the Right-Revd D.G. Loveday, at St Mary's in March 1964. Afterwards they and their parents were given tea and the chance to chat with the bishop in the Church House. Pictured with the bishop are the vicar of Banbury, Revd D.I.T. Eastman, Revd G.D. Staff and Revd C.A. Griffiths.

People of all religious denominations joined together for the Mayor's Sunday service in May 1964. It was held at St Mary's and was the first civic service taken by the newly-installed vicar, the Revd Eastman. Red Cross cadets are shown entering the church, followed by members of the Boys' Brigade.

*Left:* When new heating was installed in St Mary's vicarage in August 1964 as part of a £9,000 modernisation programme, workmen came across long-forgotten passages and a 300-year-old fireplace. The passages, which led from the dining room, were incorporated into the new central heating system. The fireplace, which was uncovered by an electrician, was said to pre-date the vicarage itself which was built in the mid-seventeenth century.

*Below:* These children from St Mary's School are shown performing at a church fair in November 1964. The fair, held in Church House, was to raise money for the parish Assistant Clergy Fund. When she opened the fair, Mrs Carpenter, wife of the Bishop of Oxford, explained that because Banbury was expanding so rapidly, additional clergy were needed and this incurred considerable expense in providing them with somewhere to live.

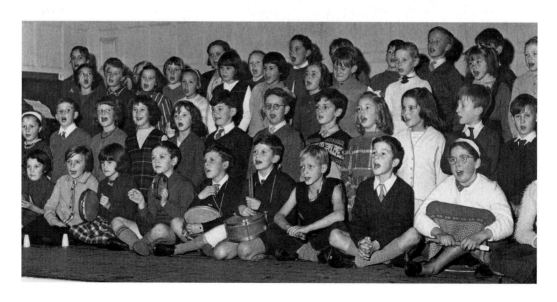

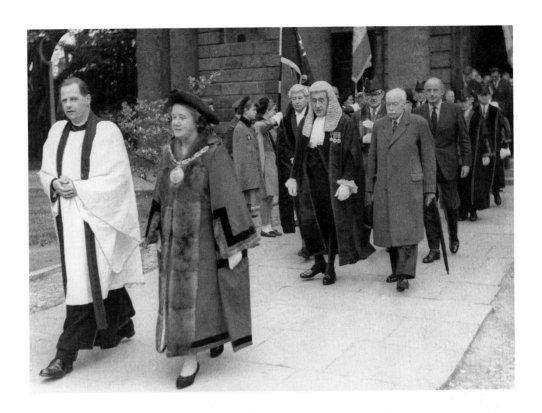

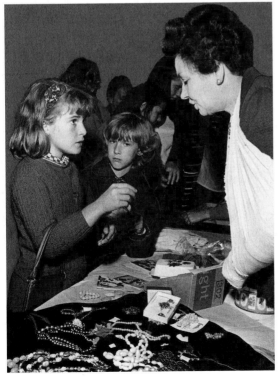

*Above:* During the civic service at St Mary's to mark Mayor's Sunday in May 1965, the Revd Eastman told the congregation that having a woman as mayor was the town's 'good fortune'. He is shown after the service escorting the mayor, Councillor Mrs G.M. Wilson; behind them are the Town Clerk, the recorder, the High Steward and Mr Neil Marten MP.

*Left:* An Autumn Fair organised by the parishioners of St Mary's in October 1969, was opened by Lord Saye and Sele of nearby Broughton Castle. The fair raised £160, which was divided between the cost of a permanent chapel of St Hugh at Easington and paying for the roof of St Paul's Church, Kidelako, Tanzania. Here young buyers look for a bargain at the jewellery stand.

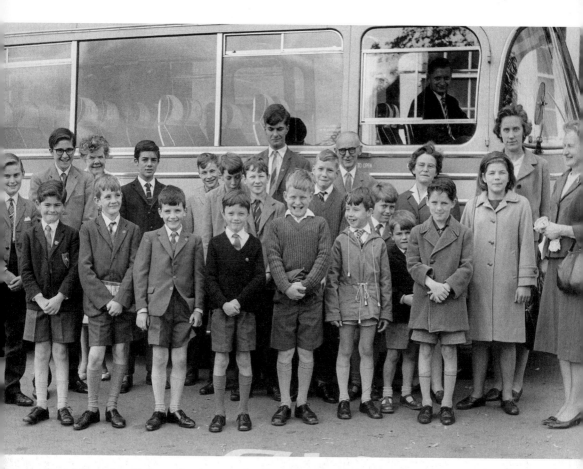

One of the perks of being a choirboy was the church outings on which they were taken. This group is shown in July 1965, posing outside the coach that would take them off to London to see the Royal Tournament at Olympia. Sadly, the Royal Tournament was discontinued after 1999 due to falling audience numbers.

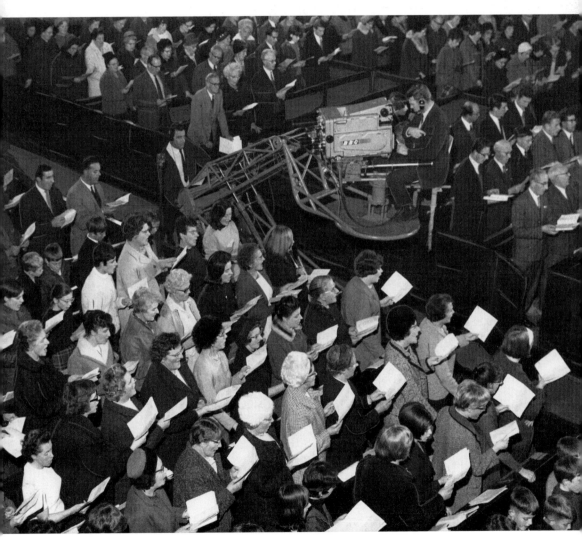

In November 1967 a BBC television crew descended on Banbury to record *Songs of Praise* at St Mary's. Two thousand people took part, and the singing was led by the town Mayor, Councillor Mrs Patricia Colegrave, and nine local choirs of various denominations. The music was organised by Malcolm Sargeant, a language teacher at Banbury School and a former conductor of the Banbury Symphony Orchestra.

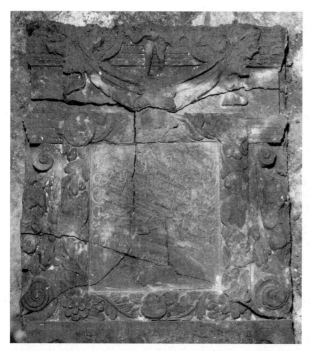

*Left:* This seventeenth-century gravestone, presumably from the ancient St Mary's Church, came to light in a house in the town in April 1970. The name of a member of one Banbury family, which he noticed on a gravestone in St Mary's churchyard, appealed so much to visiting writer Jonathan Swift that he gave it to the hero of his novel *Gulliver's Travels*, which was published in 1726.

*Below:* Temptation (in the forms of Kim Wise and Marilyn Trinder) appeared in order to persuade the vicar of St Mary's, Revd Ian Beacham, to buy tickets at the bottle stall. Mr Beacham, appropriately dressed as Mr Dombey, was taking part in the Dickensian Fair at Church House in October 1974, arranged to raise money for the church's maintenance.

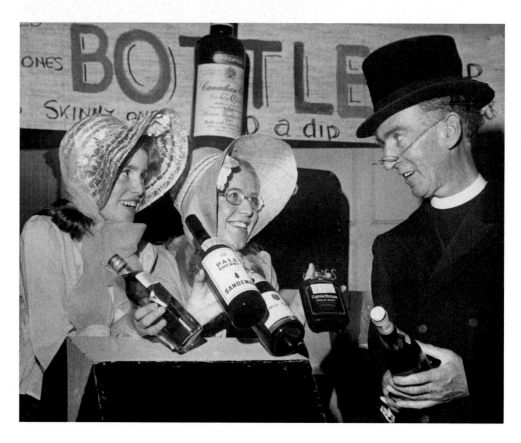

During the Easter holidays in 1963, the priest-in-charge of St Hugh's church, Easington, turned the Church Centre into a holiday school, which was attended by thirty children aged between 6 and 12. The Revd D.G. Staff is shown in his garden with some of them along with the Revd A. Roques of St Mary's, who came along to help out. Apart from having the run of the garden, the children practised their writing skills and listened to stories.

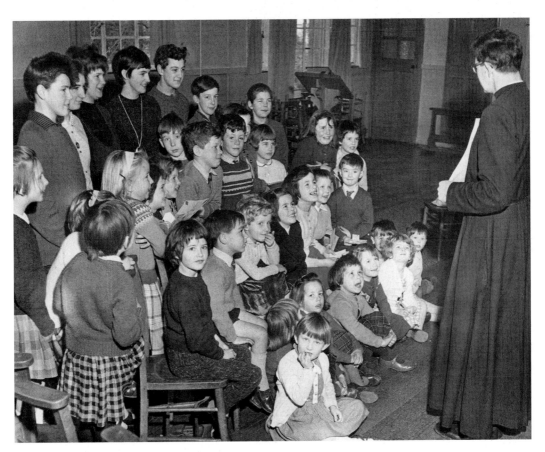

During St Hugh's Good Friday service in 1964 the Revd Staff and several helpers entertained children whose parents were attending the three-hour church service. The youngsters made models and listened to Easter stories until their parents came to collect them after church. Those in the photograph look happy enough although, not surprisingly, some are distracted by the camera.

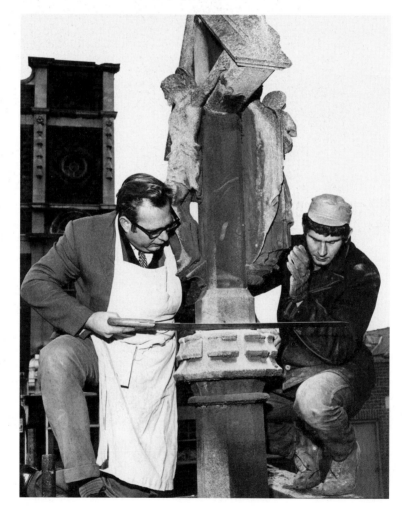

*Opposite above:* St Paul's is another of Banbury's Anglican parishes. The Warwick Road church has been in existence since the nineteenth century and in the 1960s a daughter church was opened to serve the residents of the Bretch Hill estate. When the older church was refurbished in June 1974, this concrete transporter was brought in. The floor and pews, which were infested with woodworm, were ripped out and a new floor, carpets and chairs brought in to replace them at a cost of £3,000.

*Opposite below:* This photograph shows local stonemasons Brian Harris (left) and Jeff Jones, who worked for the long-established Banbury firm, Cakebread's, sawing Christ Church war memorial into three sections prior to its being moved to the churchyard of St Leonard's, its daughter church, in December 1969. Before being demolished, Christ Church had stood on the corner of George Street and Broad Street since 1851.

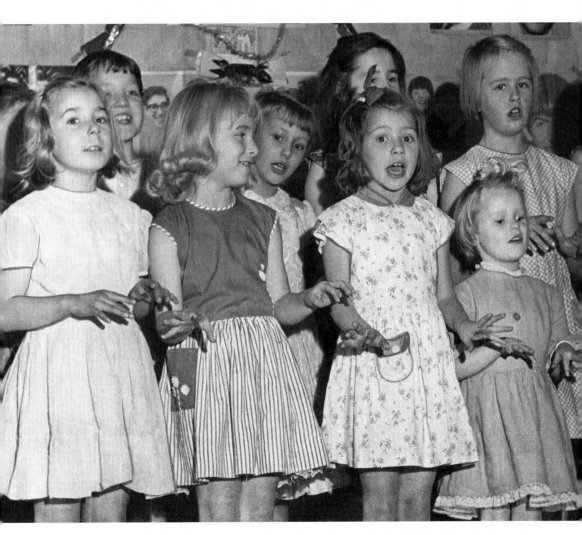

Joining in the singing of 'I am a gay musician' at a concert given in the church schoolroom in December 1963 are children from Ruscote Methodist Church Sunday School, Girl Guides and Brownies. In all, the children performed fifteen items at the concert, which was held to raise funds for their various organisations. One of the organisers stated that it was hoped that £50 would be raised.

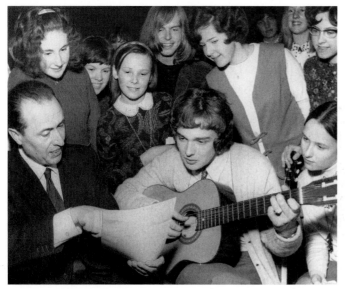

Eighteen-year-old David Galliers is shown with Malcolm B. Sargeant going through a folk song which David had written for the Banbury Council of Churches Choir Festival, which was held in the Marlborough Road Methodist Church in April 1970. The choir was made up of singers of all religious denominations in the town, which, commented a spokesman, showed 'the ecumenical nature of the festival.'

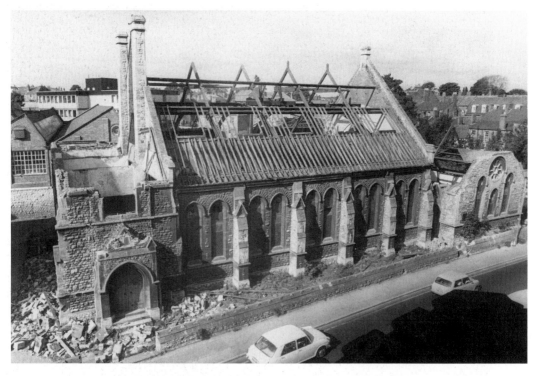

Demolition started on the Marlborough Road Methodists' Sunday school in September 1978. The site was being prepared for the construction of a superstore owned by Bishop's Food Stores Ltd over the next few months. The school was built in 1882 to cope with the demand for places as space ran out in the church rooms. In its heyday the school had 698 pupils on the roll but numbers declined until, in 1974, the school moved back into the church and its building demolished to raise money for the modernisation of the church.

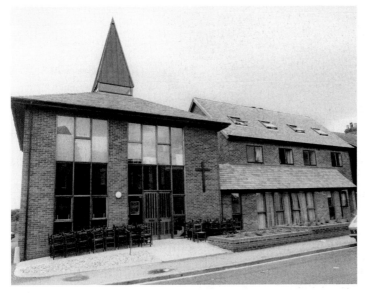

West Court, a complex of twenty-one senior citizen's flats with their own covered pathway to the church, was opened in West Street by Grimsbury Methodists in August 1986. The first Methodist Society in Grimsbury was founded in 1812 and sixty years later a chapel and schoolroom were built in West Street. When this was demolished due to decay and dry rot, it was decided to use the site for sheltered housing, a church, a Sunday school and meeting rooms.

About a hundred people came to the Harvest festival at the Congregational church in South Bar in October 1963. It was held in the schoolroom and followed church services which had been held at the weekend. The former Congregational church has been converted into a nightclub, a move which by no means all the members would have approved.

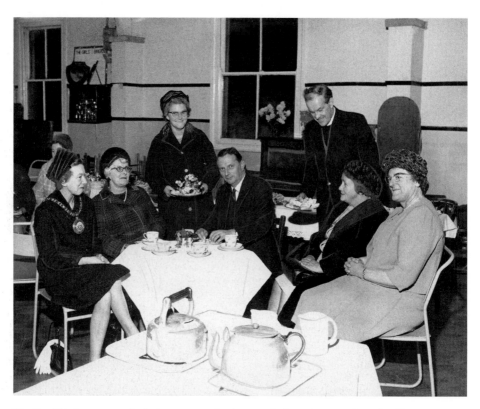

The Revd R. Spooner and a helper serve refreshments before a Baptist Church rally in
November 1967. The Revd Dr J. Ithel Jones, president of the Baptist Union of Great Britain
and Ireland is seated in the centre, with his wife and the town mayor, Councillor Mrs Patricia
Colegrave. In his address, Dr Jones stated that, 'Our society is not heinously immoral, but it is
coldly pagan; cutting itself off from its church roots.'

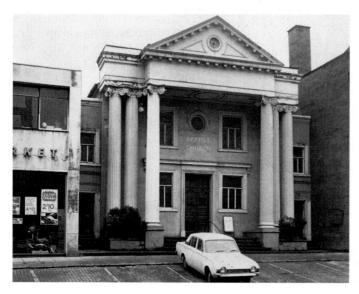

Banbury's Baptists
held their last service
in the Bridge Street
church in January
1971. Arrangements
had been made to
worship in various
other venues until
their new £80,000
church in Horse
Fair was opened.
The old church,
which had been in
use since 1840, was
sold to Fine Fare for
£84,000 to become
an extension to its
supermarket.

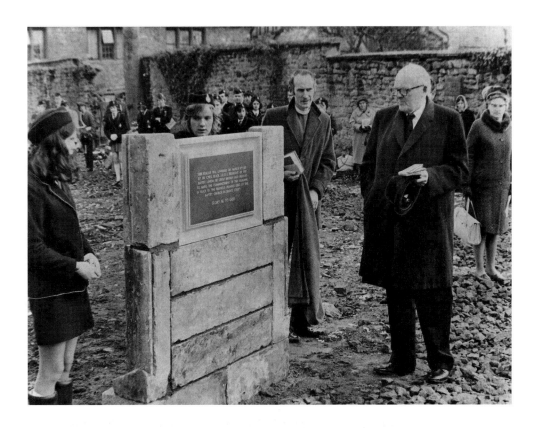

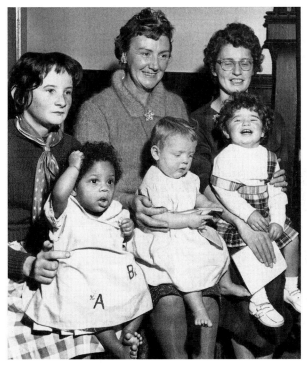

*Above:* This plaque on the site of the new Baptist church was unveiled in by Sir Cyril Black, president of the Baptist Union in March 1971. The site of the new 250-seater building had been a former Unitarian church which had been cleared by church members. Plans for the new church included five classrooms, kitchens, coffee bar, cloakrooms and even a gymnasium.

*Left:* These three prize-winning Banbury babies were among more than twenty who entered a baby show at the Roman Catholic Church's Christmas bazaar, which was held in the Town Hall in November 1961. A special 5s prize was awarded to 5-month-old Tanya O'Neal (left). Eight-month-old Jacqueline Reynolds was the winner in the junior section (centre), and 18-month-old Elizabeth Toole (right) won the senior prize.

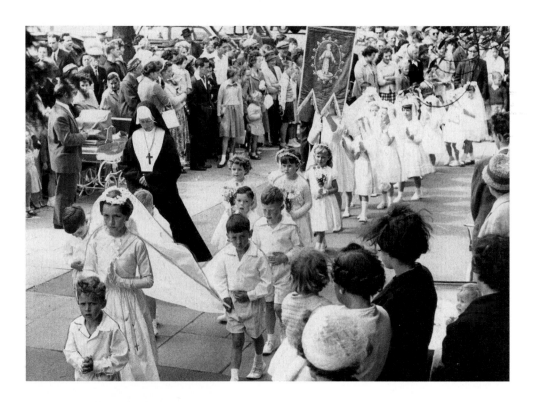

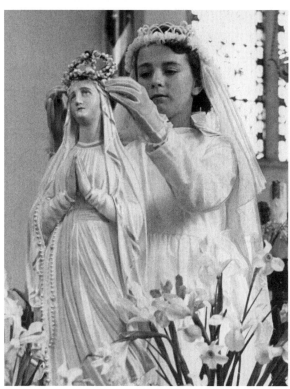

*Above:* Watched by about 200 people, Banbury's Roman Catholics celebrated the feast of Corpus Christi with an afternoon procession in June 1962, followed by an evening mass. Lead by the crucifer and acolytes, the Blessed Sacrament was carried through the streets around St John's Church. Also in the procession were the May Queen, 12-year-old Brigitte Watts of Wardington, and her attendants who threw flower petals along the way.

*Left:* The following year the May Queen was 11-year-old Susan Howes of Gillett Road, who is shown here dressed in all her finery in May 1963, placing a garland on a statue of the Blessed Virgin Mary in St John's Roman Catholic Church. Susan herself was crowned in a special service in the church.

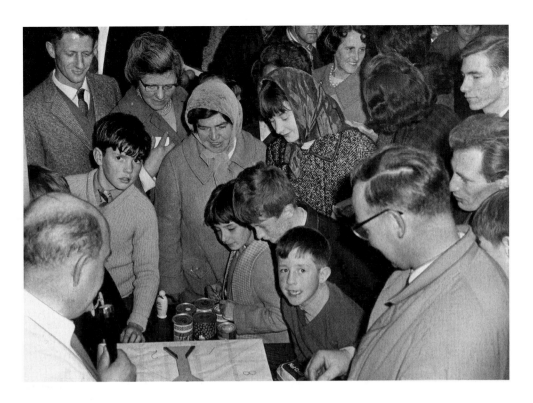

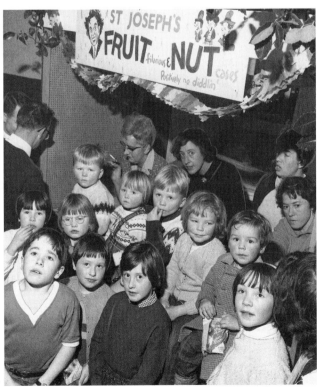

*Above:* More than £100 was raised by St John's Roman Catholic Church at their annual autumn bazaar in the community centre in November 1964. The event was opened by Lt-Col C. Russell, Commanding Officer of USAF Croughton. Pictured here are visitors playing a game of roulette on a home-made wheel.

*Left:* In 1967, the Roman Catholic church in Banbury had to find 25s per head of its congregation to support the four Catholic schools in the town. To raise the £4,000 needed each year, a Christmas bazaar was held at St John's community centre. The banner is a reference both to comic Ken Dodd's Diddymen who were very popular at the time and the television advert for Cadbury's Fruit and Nut chocolate bars.

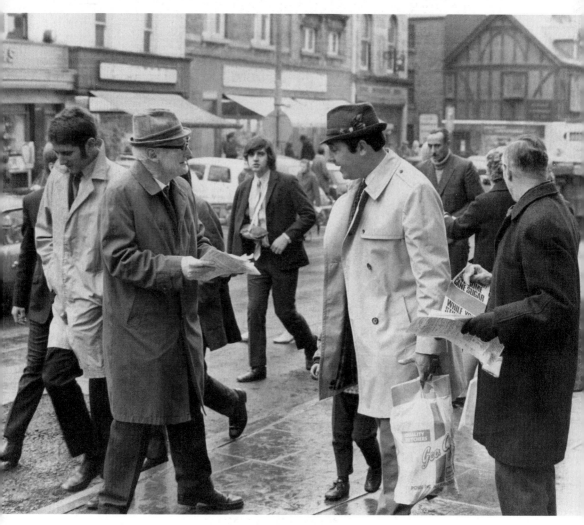

Surprised shoppers were handed 2oz packets of sugar in November 1970 in an anti-Common Market demonstration staged in the town by members of the World Development Action Group of the Banbury Council of Churches. The action group sought to warn people of the dangers of Britain's joining the Six. The sugar packets represented the smaller Commonwealth sugar-producing countries which were likely to suffer by Britain's entry, which would necessitate the purchase of European beet sugar.

# ᪣ 6 ᪣

# CARNIVAL AND RAGTIME

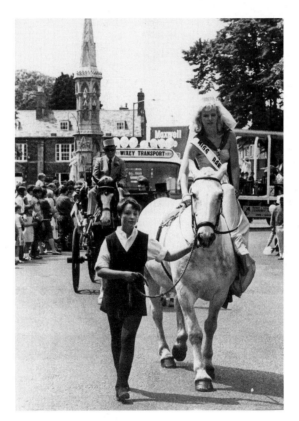

In 1983 the future of the Banbury carnival was uncertain due to financial considerations, but the day was saved when developers Federated Homes offered Banbury Round Table sponsorship of up to £1,500. That year, the carnival, which was sponsored by General Foods Ltd, raised about £200 for various charities. The theme was nursery rhymes and what better example could there have been than Miss Banbury, Michelle Reed, riding side-saddle on a large grey named Corporal?

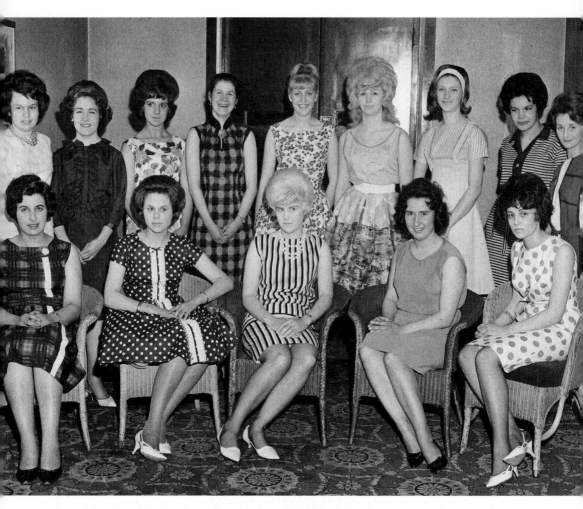

Classic 1960s bouffant hairdos, stilettos and winkle pickers are to be seen in this line-up of the fourteen girls who took part in the contest for the title of Carnival Queen in May 1963. They are, standing from left to right: Bette Davis, Rosamund Starling, Janet Cowie, Julie Palmer, Mary Gillett, Carole Lambourn, Jane Thirst (winner), Patricia Ford and Sonia Lacey. Seated: Beryl Flowers, Rosa Pratt, Pearl Hart, Susan Cooper and Susan Grant.

*Opposite above:* The theme for 1969 was best-selling books for children and students of all age groups took part. Rag Queen Cherry Wincott and her attendants are pictured leading the convoy of floats. That year's rag was described as the biggest and noisiest that Banbury had seen to date, but it was also the most organised. The amount raised was £650, £50 more than had been anticipated, which went to Voluntary Services Overseas projects in New Guinea.

*Opposite below:* A never-to-be forgotten moment came for Judy Jackson in March 1971 when she was elected Rag Queen. Not only was she crowned by radio disc jockey Johnnie Walker, he also gave her a big kiss on camera. Pictured with the 16-year-old Office Studies student are the other finalists, from left to right: Libby Pick, Sally Hinton, Cathy Webb, Katherine Hitchens and Alison Shephard.

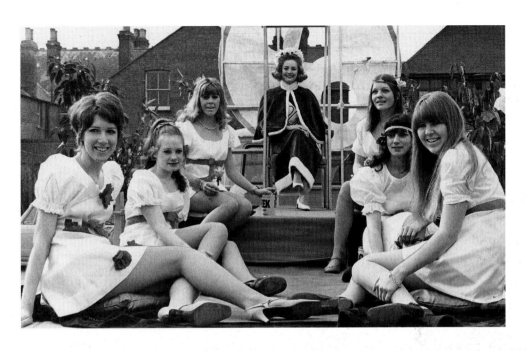

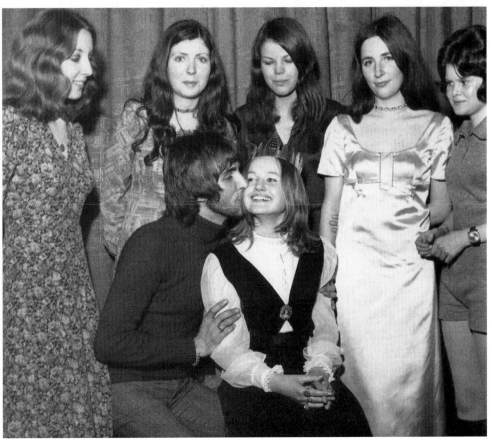

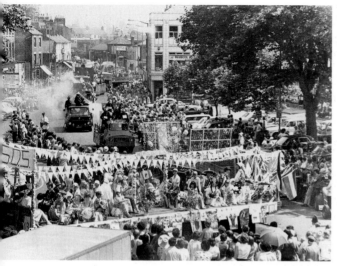

In June 1976 the carnival was accompanied by a heatwave, but there was still a massive turnout to watch the proceedings and afterwards the Rotary Club was delighted to announce that hundreds of pounds had been raised for charity. Roads into the town were blocked with traffic as the procession made its way through the streets. The ambulance service was stretched to capacity as nine people who had collapsed received treatment and one woman fell into the canal and was later charged with being drunk.

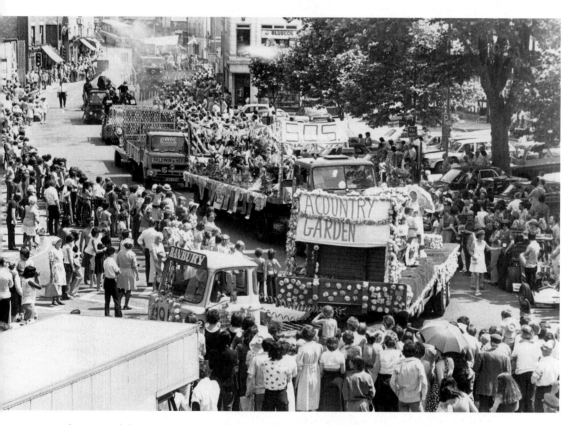

Another view of the procession in 1976. An ambulance man said it was one of the busiest times he'd known in eighteen years. Between 6,000 and 7,000 people went along to Spiceball Park to see the highlights, which included five-a-side football on motorbikes and a performance by a Planet of the Apes team. Unfortunately one apeman fell off his horse and dislocated his shoulder and a hot-air balloon display was cancelled due to the heat.

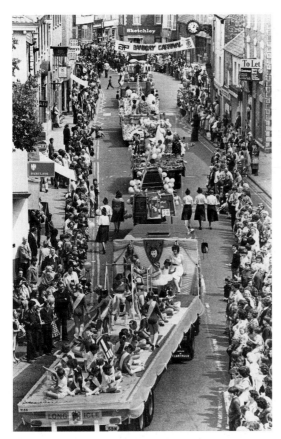

*Left:* In June 1979 a record crowd of more than 10,000 people enjoyed the carnival, which was sponsored by Automotive Products and organised by Banbury Round Table. It opened with a performance by the Red Devils free-fall parachute team. This went well, but a planned kite display had to be cancelled due to lack of wind. Luckily, four sheep from North Wales, handled by British Champion Merion Jones, were able to put on a show. Other attractions included dancing, a pipe band and a hot-air balloon.

*Below:* In June 1980 Miss Banbury, Mandy Carruthers, led a procession which included forty floats and no less than six bands through the main streets on their way to open the carnival. Volunteers armed with buckets went among the crowd collecting money and any profit from the carnival went to the charity fund of the organisers, the Round Table. Here is Humpty Dumpty, still perched on his wall.

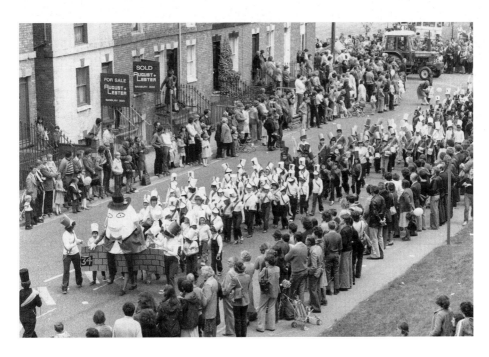

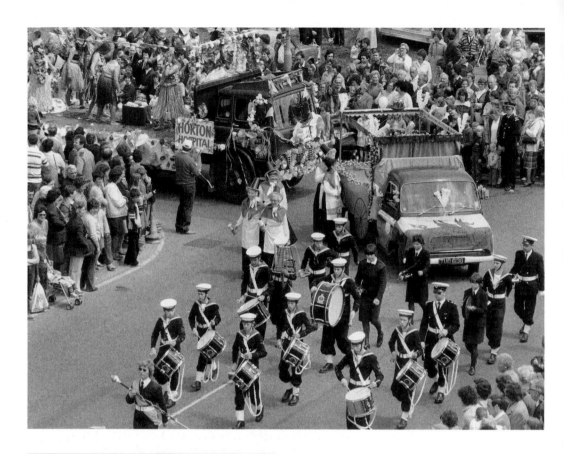

*Above:* This photograph shows the Sea Cadets' Band taking part in the 1981 carnival. Behind them a van decorated with the Prince of Wales's feathers and a proud Welsh dragon was accompanied by ladies in Welsh costume. The Horton Hospital float which followed them brought an exotic international touch with dancers in grass skirts and leis round their necks.

*Left:* Horton Brownies chose the *Mister Men* books as their theme in 1981. That year the carnival got off to a shaky start when one of the star attractions, a Cessna aircraft carrying the Barnstormers parachute team, lost its tail wheel which had to be repaired before their arrival in Banbury. In addition to this, on its way to join the procession, one of the floats ripped down telephone wires in Queensway, putting twelve telephones in the vicinity out of action. Despite these setbacks, the event was a huge success.

These cheerful Brownies from the St Paul's pack appeared in the 1986 carnival. Oganisers had been worried that the event would not take place due to lack of sponsorship but at the last minute Albert Windows came forward with £1,000 so that the show could go on. Highlights were an aerobatic display over Spiceball Park, a tug-of-war and an appearance by Don Estelle star of the television sitcom *It Ain't Half Hot Mum*, who sang to an audience of 1,000.

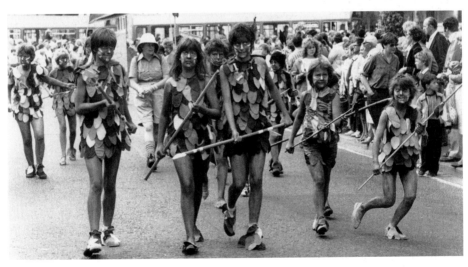

Banbury Guides march their unfortunate prisoners through the streets in a carnival parade made up of fifty floats in June 1984. Principal attractions that year were the Regimental Band of the Irish Guards, Brian Bowden of *One Man and His Dog* television fame whose sheepdog rounded up ducks and, less well known, a young lady called Miss Dynamite and her exploding coffin.

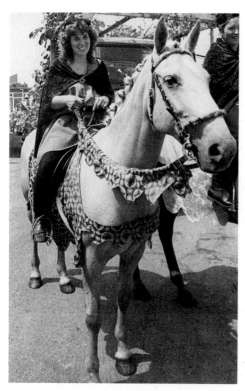

*Left:* In 1989 the Cheshire Home float was led by Jane Barton astride a real white horse. The main feature of the event this year was a contest based on a popular television series of the time, *It's a Knockout*, and the Banbury version was won by a team from the local branch of the Kärcher Company.

*Below:* In 1989 the white horse was in danger of being upstaged by a very lively dragon which threatened to gobble up a Fine Lady and had to be kept in order by a St George on roller skates. Although there were a lesser number of floats taking part that year the carnival was nevertheless rated a huge success. The award for the best float went to Banbury Grime Prevention panel.

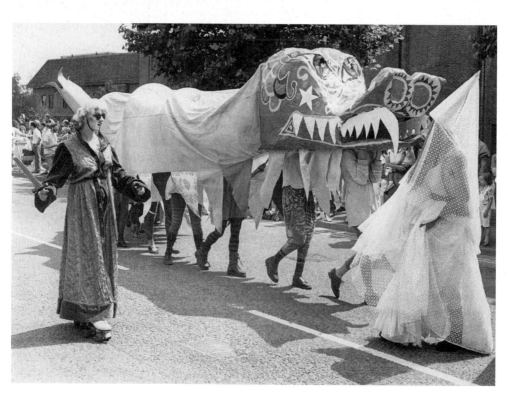

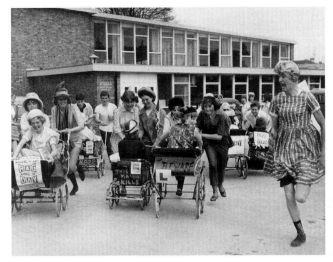

Students at North Oxfordshire Technical College and School of Art had their own way of raising money for the Pestalozzi Children's Fund – by holding a rag week. In April 1965, their rag was publicised by a ten-mile pram race round five nearby villages: Great and Little Bourton, Cropredy, Williamscote and Chacombe. The Principal, Mr N.A. Pratt, started the race, in which more than 100 students took part in seven teams, each with some sort of pram-like transport. The winners were the second-year GCE group who completed the course in 1 hour 25 minutes.

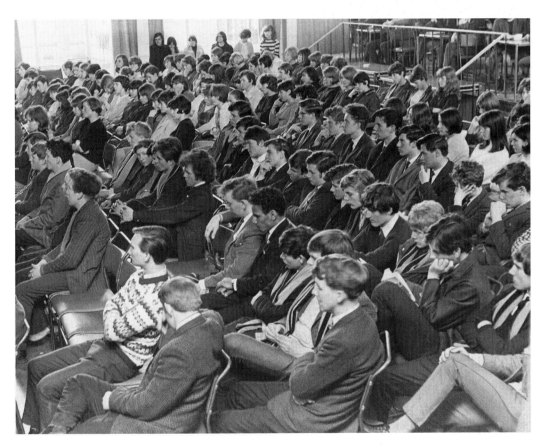

In 1966 the Royal Commonwealth Society for the Blind was the charity chosen by North Oxfordshire Technical College students. The Society sent a representative to speak to students gathered in the college theatre about its work and told them that their efforts 'would add a spurt to what has become a fire in the combat against blindness.'

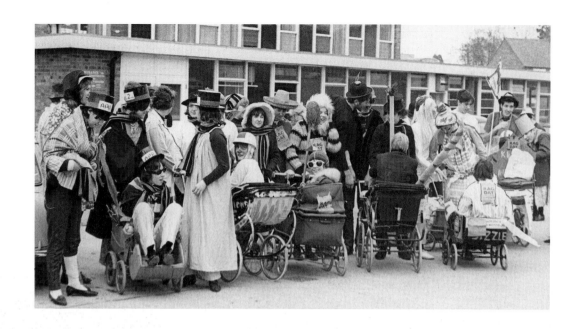

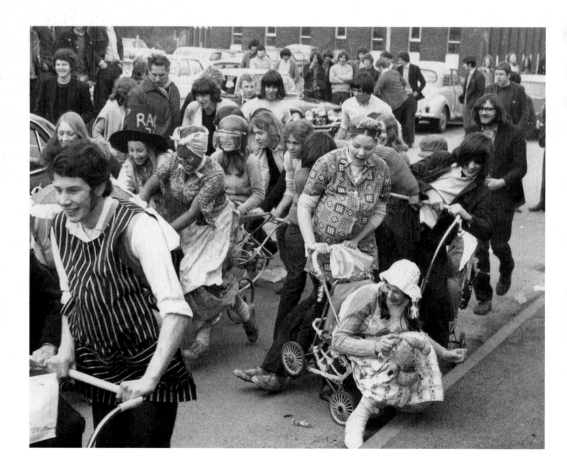

*Opposite above:* Those taking part in the Perambulator Stakes in March 1966 were informed officially that the going was 'very hard'. The competitors are shown waiting for the starting gun dressed in an assortment of clothing and pushing or occupying a range of unlikely vehicles vaguely resembling prams.

*Opposite below:* This pram and its occupant are about to crash into the pavement soon after the start of the race in April 1971. Carried out in fancy dress, the race was to publicise the rag activities later on in the week. The entrants set off behind a police panda car for their 3-mile circuit of the surrounding villages. Some of the vehicles were armed with bags of flour to hurl at would-be over-takers. Money raised went to the Save the Children Fund and Horton General Hospital.

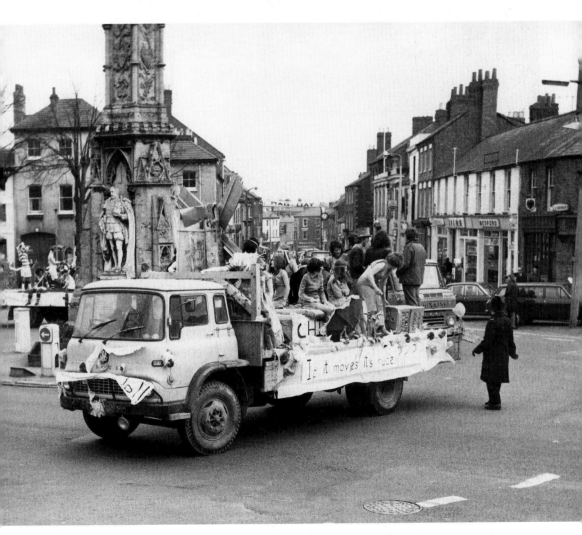

The Rag procession of floats making its way round the Cross with the help of a policeman on point duty in April 1971. The slogan on the banner on the side of the lorry – 'If it moves it's rude' – is a reference to the fact that in the days of censorship by the Lord Chancellor, 'artistic' performances like those at the world-famous Windmill Theatre were permitted as long as the artistes remained stationary.

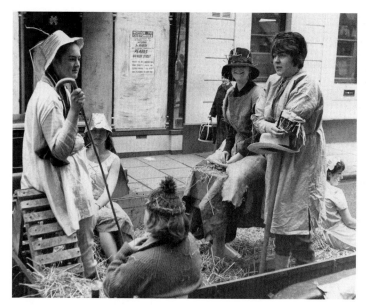

Taking a break on one of the tableaux in the 1966 procession. The fact that the rag day procession passed 'without incident' was stated by a senior police officer, who described it as 'one of the quietest.' The Student Association had previously given the Borough Council an undertaking to 'curb their activities' after a threat to ban the rag day following incidents in previous years.

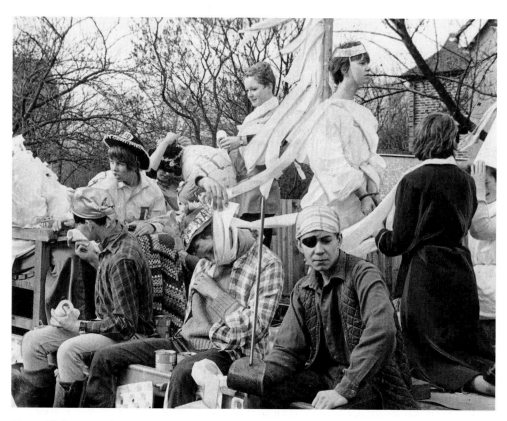

This unlikely group of pirates, cowboys and martyrs were only a few of the students taking part in the 1967 rag when the theme was 'Through the Ages'. Other characters were prehistoric men, convicts with balls and chains, nurses in various uniforms and dolly birds in mini skirts and Easter bonnets.

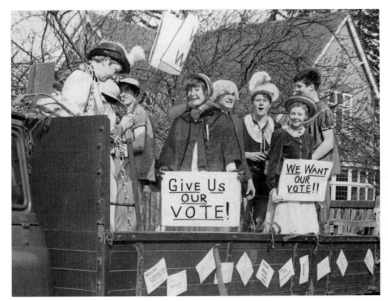

Also part of the theme of 'Through the Ages', these suffragettes on a lorry appeared in 1967 to demand both votes and cash for their chosen charity (Save the Children) and the amount raised was £500.

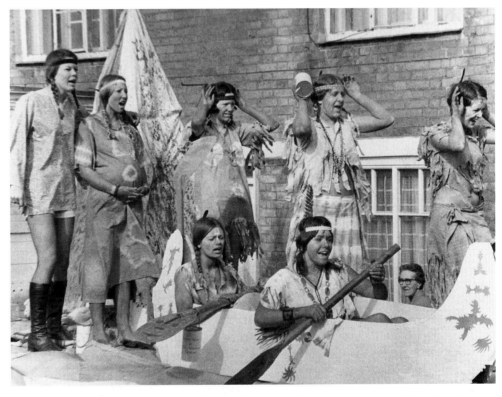

These students dressed as squaws, complete with canoe and tepee, occupied one of the nine floats which made up the rag day procession in March 1972, when the theme was the various countries of the world. It was one of the quietest rags; a police officer said that he did not know why the police were on duty there that year.

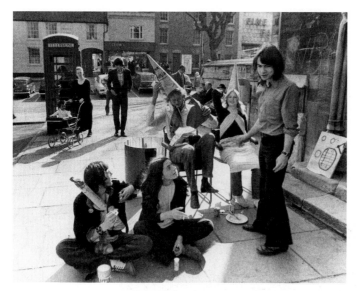

Despite a last minute hitch due to a change of performance to Saturday instead of on a weekday to avoid disruption to their studies, all went well when students put on a play as part of rag week 1972. This took place in the town centre where shoppers watched the performers giving their views on present-day social problems in the town. Donations were given to Voluntary Service Overseas and the Banbury Society for the Mentally Handicapped.

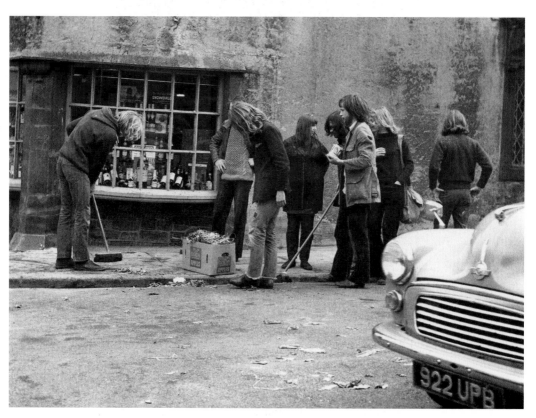

And then came the aftermath. Students from the Tech cleaning up after a session of throwing eggs, flour and rotting vegetables at shops in the town centre during the procession in April 1971. The offenders were disciplined and it was stressed that these were a minority. Acting on complaints received from the public, Thames Valley Police asked the Borough Council to ban future rag processions through the town.

# ᶞ 7 ᶞ

# THE YOUNG ONES

As a pre-Christmas treat in December 1966, 3½-year-old Jeremy Odle and his brother James, aged 2, were allowed a ride on this motor car, which made the most realistic noises. The boys and their mother, Mrs Jean Odle, had come in to Banbury from Bodicote. The local press reported that in the 1960s many workers in Banbury came from outside the area but went home at Christmas, leaving the town relatively deserted.

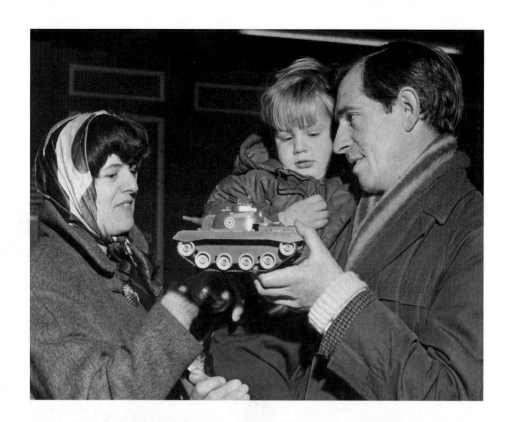

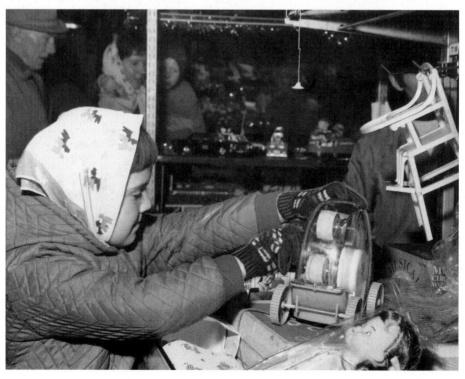

*Opposite above:* All three members of this family seem taken with this working model of a tank, which was just one of the Christmas toys on display in the shops in November 1966. The little boy, 3½ year-old Christopher, clearly hopes that Mum and Dad, Mrs and Mrs John Evans, will ask Santa to leave it in his stocking.

*Opposite below:* Who says that it's just dolls for girls and cars for boys? This little girl is obviously fascinated by whatever she is playing with, shortly before Christmas 1968. That Christmas the Post Office was expecting a record amount of mail, with an estimated 900,000 to a million cards and parcels being handled.

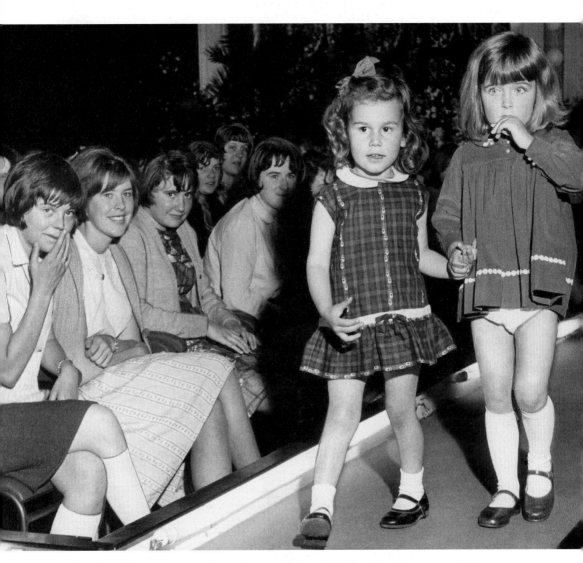

Although the dress designers whose ideas were featured at this student dress show in June 1965 were only in their teens, the models were much younger. When they appeared on stage in front of a live audience these two clearly needed to hold hands to give each other confidence. Maybe the mini skirt on the right was just a little too short?

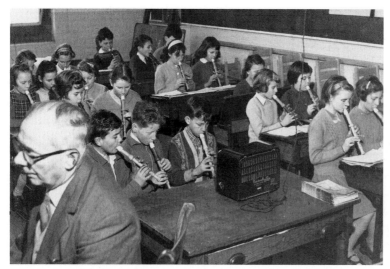

The headmaster of St Leonard's School, Mr A.R. Spicer, is shown in February 1962 playing the piano for the school's recorder band during the St Leonard's centenary celebrations. The primitive wiring arrangements leading to the radio set would certainly not be permitted today.

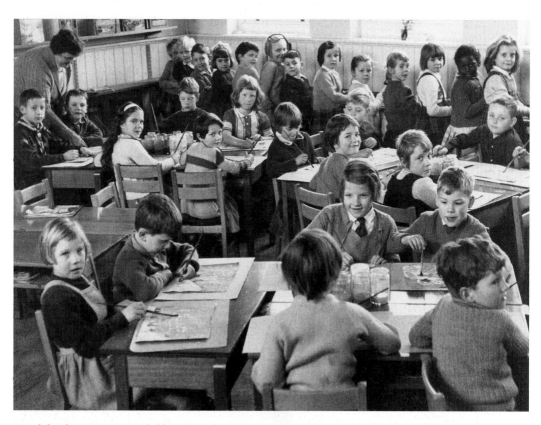

Six of the thirty American children from the Dependents' School at the USAAF base at Upper Heyford joined a painting class at St Mary's School when they visited in February 1962. The rest were attached to other classes. The exchange was organised by St Mary's headmaster Mr E.W. Johnson and Mr J. Heinlein from the base. The following week an exchange visit was paid to Upper Hyeford.

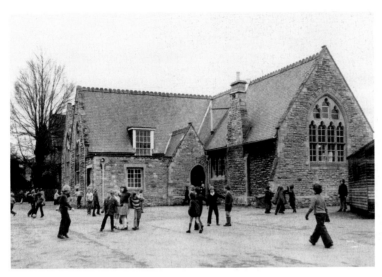

When St Leonard's School (the second oldest school in the town) closed in the spring of 1976, its 200 pupils moved to the new St Leonard's to become part of Banbury School, leaving the building empty for the first time in 113 years. When it opened in 1862, it was known as Christ Church School. An exhibition showing the school's history was organised and old boys and girls, some of whom were wartime evacuees, were invited to attend.

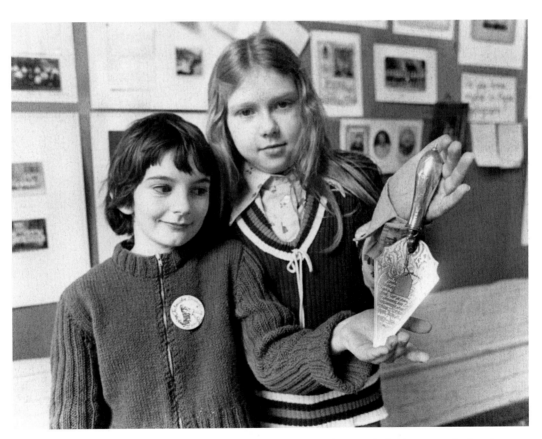

Ellen Ducket and Joy Pheasey, both aged 10, pictured with the trowel which was used to lay the first stone of St Leonard's School, Grimsbury. It formed part of the exhibition arranged to mark the school's closure after 113 years. A thanksgiving service for the school was conducted by the vicar, the Revd Raymond Hayne.

Shortly before St John's Priory Roman Catholic School closed after 143 years in July 1990, more than 500 past pupils, parents and parishioners took part in a Thanksgiving Mass conducted by Monsignor Pat Corrigan. Pictured with some of the last pupils to attend the school and Monsignor Corrigan is Sister Catherine, who holds a plaque dedicated to all the Sisters who had taught at St John's over the years and which had been donated by parents.

*Opposite above:* By the mid-1960s, membership of the Sea Cadet Corps and Girls' Nautical Training Corps had increased to the point that they had outgrown their headquarters in Church Lane. To help raise funds for a move to larger premises, a fête and tattoo was held in July 1965 at the Blacklock Arms Hotel. When they arrived for the opening, the Mayor and Mayoress were 'piped aboard' by the cadet band. Visitors are shown trying to cover half-crowns with pennies in a tub of water.

*Opposite below:* This trio of young carol singers dressed up in blue and called themselves the Bluebells. They are shown entertaining visitors at the Elms Clinic's Christmas bazaar in December 1964. They are, from left to right, Christine Beer, Neil O'Kelly and Karen Lafferty. The event raised more than £100 which went to provide amenities for the patients.

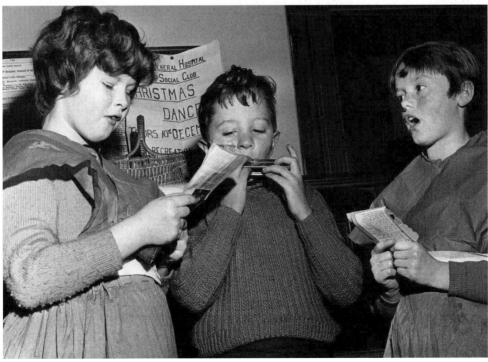

In January 1976, these children from Neithrop Junior School carried out a project to discover how much the town's shops and amenities had changed over the past century. They are shown in South Bar making a list of the current shops, helped with their teacher, Miss Deidre Scott. They decided that the landmark which had changed the least was Banbury Cross.

Another part of the project undertaken in June 1982 by pupils of William Morris School on past and present aspects of their home town was the construction of a model of a market stall. This was filled with all sorts of fruit made of papier-mâché and the young modellers are shown advertising their wares, all of which were marked up at current market prices.

The end of an era arrived in May 1983 with the closure of another Banbury school, Britannia Road Infants School. Founded by Sir Bernard Samuelson, it opened in 1861 to cater for the children of workers at the town's foundry. The sixty-four pupils were transferred to Dashwood Road Primary School only yards away. The school buildings were converted into a day centre for the elderly and a nursery unit to replace the one in The People's Park.

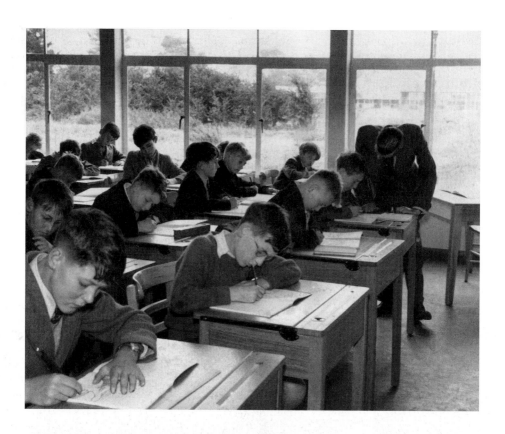

*Opposite above:* Working away in their new classroom at the beginning of the school year in 1956 are these first-formers from Easington Secondary Modern School for Boys. However, the boys were not to have the building all to themselves for very long as several hundred girls arrived to share the building the following January.

*Opposite below:* Pupils of Hill View Primary School took part in the town's multi-cultural week in June 1990 by welcoming as their guest Laja Adedogin from Nigeria. Four resident artists were involved in the event, with demonstrations of Nigerian pottery-making, dancing, batique and other crafts. Other attractions were American softball, international cookery demonstrations, Ghanaian dance and drama, clog dancing and real ale from the nearby Hook Norton Brewery.

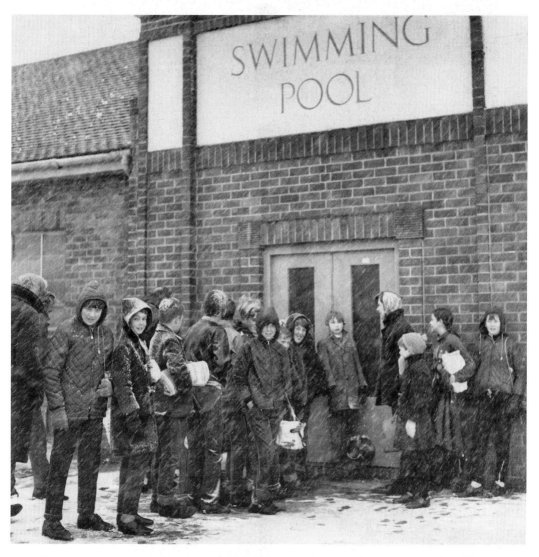

It was no joke waiting in the snow for the Banbury swimming pool to open on April Fools' Day 1970. Despite the snow, quite a queue of youngsters, ready to take to the water whatever the weather, formed up outside the open-air, unheated pool.

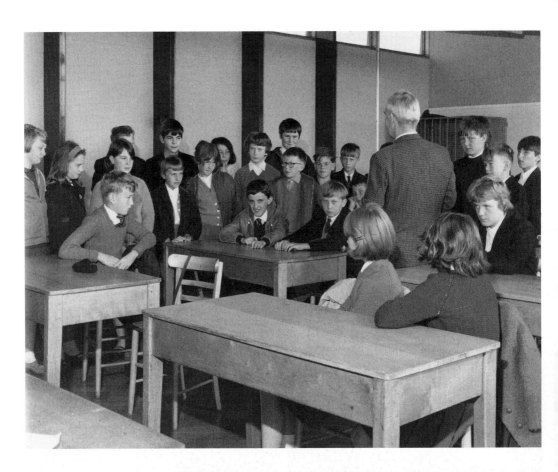

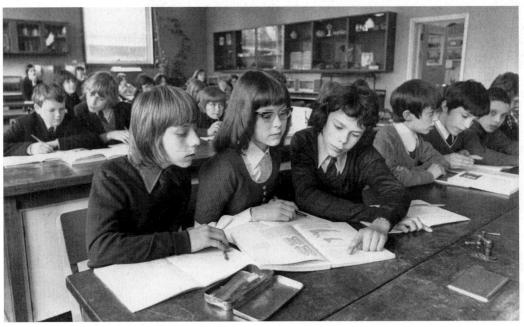

*Opposite above:* Founder-pupils of Banbury School, the town's first comprehensive, which came into being in September 1967. They are shown with their form-master, Mr E. Pethebridge in Wykham Hall. The new school, which was made up of the former Grammar School, and Easington and Grimsbury secondary schools, had 1,800 pupils in four Halls or communities, and was set to expand to 2,040 by 1971. A school uniform was not introduced until the following year.

*Opposite below:* By March 1975 Banbury School was so short of textbooks that pupils were forced to share books, in the case of a chemistry class, one copy between five children. A Banbury Schools Book Fund was launched with the aim of raising £1,500. It was the brainchild of John Sayer, Principal of Banbury School, and Richard Hartree, a director of Alcan Research and Development, with the aim of obtaining financial backing from parents and local businesses.

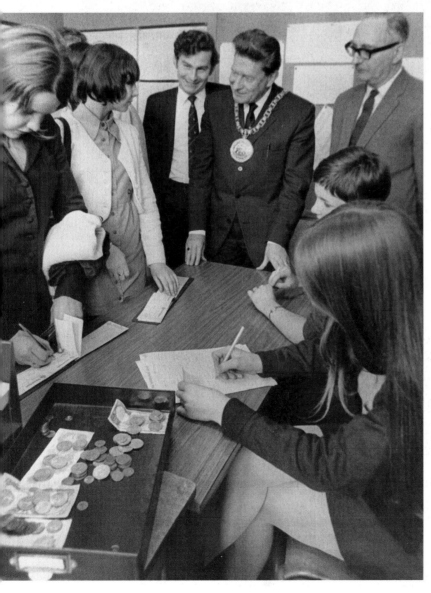

The mayor of Banbury, Councillor Richard Keys, visited a bank run by pupils of Wykham Hall, Banbury School in March 1972 as the guest of members of the Banbury and district schools savings committee. The bank was set up to cater for the needs of the savings group composed of local youngsters, and Wykham Hall was the first secondary school in North Oxfordshire to start such a group.

*Opposite above:* When Banbury School entered a team in the Trans-World Top Team Competition in August 1972, Susan Thomas discovered that unbeknownst to either of them, she was related to a girl on the team representing Llanelli. She is shown talking to her relative, Lynda Evans, and question master Geoffrey Wheeler. The Banbury contestants were one of three British teams which played three Canadian teams.

*Opposite below:* In May 1972, fourteen second-year girls at Grimsbury Hall who had formed a choir put up a 'Wanted' notice for boy singers to join them. The girls, led by Susan Appleton, were photographed when their appeal was featured in the local press due to the fact that they had had received no responses to date.

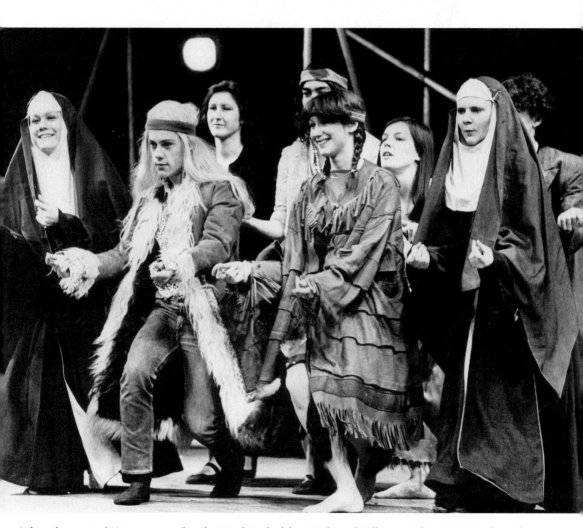

When the musical *Hair* was staged at the North Oxfordshire Technical College in February 1982, four of the nineteen-strong cast of nine boys and ten girls declined to appear in the ninety-second-long scene where the actors bare all. In spite of this, advance ticket sales were said to be booming and overtaking those for the previous year's offering, *Cabaret*.

*Above:* A new PAYE (Pay As You Eat) system of school dinners was introduced at Banbury Upper School in June 1980. Set to replace the old set menu, there were several choices on offer, any of which could be bought separately and payment made at a cash desk. As well as the traditional set meals, these pupils were able to select snacks in the school canteen, with cheese on toast at 12p and puddings for 35p.

*Left:* Six young investors from Banbury School were the winners of Oxfordshire's Stockpiling competition in April 1978. Pictured are A-level Economics students Nigel Price (with bowler and umbrella), Mark Ingledew, Anne Taylor, Valerie Wood, Robert Sherington and James King. They won by increasing their initial investment of £20,000 to £26,225 over a six-month period. Unfortunately for them, the title and a trophy was all they won as the exercise was only theoretical.

Serious faces at the North Oxfordshire Technical College prize-day in March 1967. The speaker, Mr F.H.J. Wileman, Secretary-General of the Corporation of Secretaries and Vice-Chairman of the South Regional Council for Further Education, said that the allegations that Britain was decadent were nonsense. This, he added, was proved by the achievements of the students themselves who had that year taken 2,239 examinations, with 1,428 passes, 456 of them with distinction.

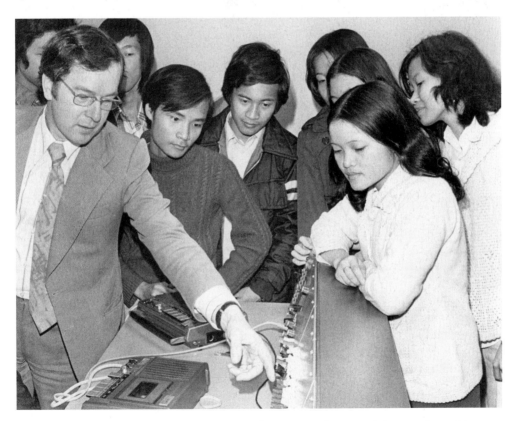

These eight youngsters from Vietnam, who arrived in Britain as boat people, were welcomed to Banbury by the Mayor, Colin Taylor, in October 1979. They stayed with local families and were given free English lessons at the English Language Training School. The offers of accommodation would have housed as many as forty refugees and some people even asked if they could adopt the children. They are shown here with the Language School's Dr Terence Gerighty, who is demonstrating how to use the equipment in the language laboratory.

# Other titles published by The History Press

## Oxford in the 1950s & '60s

MARILYN YURDAN

*Oxford in the 1950s & '60s* offers a rare glimpse of life in the city during this fascinating period. As this amazing collection of 200 photographs shows, there is much more to these two decades than pop groups and mini skirts. Including views of Oxford's streets and buildings, shops and businesses, pubs and hotels, the Colleges and University departments, as well as some of the villages which form the suburbs of the city, this book is sure to appeal to all who remember these decades and everyone who knows and loves Oxford.

978 0 7524 5219 7

## Oxfordshire Graves and Gravestones

MARILYN YURDAN

Local author Marilyn Yurdan takes the reader on a tour of the county's graveyards, including the largest Anglo-Saxon cemetery in England and a Medieval Jewish cemetery under Oxford Botanic Garden, and reveals the poignant, humorous, and sometimes gruesome history behind Oxfordshire's graves and gravestones. Among the gravestones featured here are those commemorating politicians, academics, soldiers, artists, poets and writers, as well as some more unusual people, including the first English balloonist, the soldier who fired the first shot at Waterloo, and a Maori lady.

978 0 7524 5275 9

## Street Names of Oxford

MARILYN YURDAN

This book traces the origins of names found in Oxford, not only of its streets, villages, suburbs and housing estates, but also of the various colleges which make up the university, many of which have had a considerable influence on its streets. Containing illustrations that range in date from nineteenth-century prints to photographs of modern developments, this book is a must-read for everyone interested in Oxford's development.

978 0 7509 5098 5

## An Oxfordshire Christmas

DAVID GREEN

This seasonal anthology of festive fare will delight Oxfordshire readers. Here are reminiscences of Christmases past at Blenheim Palace and Broughton Castle, and, contrastingly, the simpler pleasures enjoyed at Flora Thompson's rural Lark Rise. Pam Ayres and Mollie Harris mingle in this anthology with distinguished Oxford scholars, J.R.R. Tolkein, Robert Southey, John Donne and Joseph Addison, and share with us their experiences of yuletide. This book also includes ghost stories, local carols, traditions and folklore.

978 0 7524 5313 2

Visit our website and discover thousands of other History Press books.

**www.thehistorypress.co.uk**

The History Press